Illustrating
Children's
Picture Books

ILLUSTRATING CHILDREN'S PICTURE BOOKS. Copyright
© 2009 by Steven Withrow and Lesley Breen Withrow.
Manufactured in China. All rights reserved. No other part
of this book may be reproduced in any form or by any electronic
or mechanical means including information storage and
retrieval systems without permission in writing from the
publisher, except by a reviewer, who may quote brief passages
in a review. Published by Writer's Digest Books, an imprint of
F+W Media, Inc., 4700 East Galbraith Road, Cincinnati,
Ohio 45236. (800) 289-0963. First edition.

For more excellent books and resources for writers,
visit www.fwbookstore.com.

13 12 11 10 09 5 4 3 2 1

Distributed in Canada by Fraser Direct
100 Armstrong Avenue
Georgetown, Ontario, Canada L7G 5S4
Tel: (905) 877-4411

Library of Congress Cataloging-in-Publication Data

ISBN: 978-1-58297-620-4

Cover illustrations:
Front (from left to right): © Lesley Breen Withrow,
© Polly Dunbar, and © Miriam Latimer, from Emily's Tiger,
reproduced by kind permission from Barefoot Books
www.barefootbooks.com
Back: © Sophie Blackall.

"Children are a much more demanding audience
than grownups because, when you are working
for adults, you are really working for yourself as
an artist; you can make the assumption that the
reader will make connections and fill in the blanks.
When you're working for a kid audience, you have
to be aware of the reader and his or her mode of
perception. You form a dialogue with a child where
you can't be ambiguous, you can't be unclear. You
add all the detail and the texture you can to the
storytelling, but you have to be pinpoint on."
—Françoise Mouly, art editor of *The New Yorker*
and founder of *RAW*, RAW Junior, The Little Lit
Library, and TOON Books

Design by Tonwen Jones
Art Director Tony Seddon

Illustrating Children's Picture Books

Steven Withrow
and
Lesley Breen Withrow

WRITER'S DIGEST BOOKS

Contents

Introduction

At this moment, somewhere on Earth, an illustrator is putting the finishing touches to a picture book meant for a child. Elsewhere, another artist is dreaming up the seed of an idea that will one day grow into a wildly popular picture-book story. The two have little else in common. Their methods and materials are markedly different. The worlds outside their windows couldn't be farther apart. But they both share one desire: the ambition to communicate their own special visions in intertwined images and words.

Perhaps one of those artists is you—you're already toiling away at a masterpiece in the making. Or perhaps you're reading this introduction wondering, "How do those artists do it? Where do they start? What comes after? Why do they make the choices they do? When do they know they've got it right?" This book will help you answer these questions.

Having said that, this book doesn't tell you, "This is how you should write or illustrate a picture book." What works for one book will not necessarily work for the next. And one artist's genius might be your undoing. Nor can we tell you precisely how to get a picture book published, how to interest an agent, or how to be certain your book will remain in print or sell 100,000 copies. There are simply too many ways to break into the world of picture books and build a career; there's no secret formula. All things considered, we believe it's best to be yourself and to learn by experience what it means to become a professional. Also, there's nothing wrong with staying an amateur and creating art for the fun of it. Children's literature, if not the children's book market, is open to all.

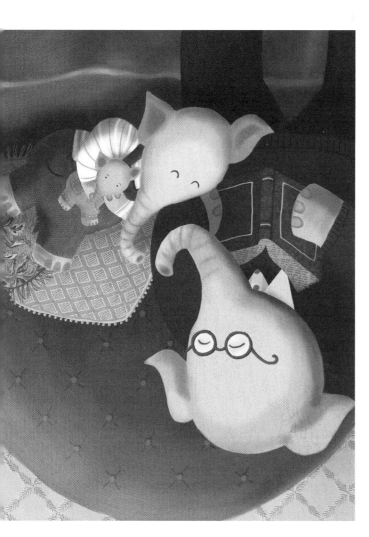

This book doesn't lock you into a definition that says, "This is exactly what a picture book should be." It's hard enough to agree on what a picture book is and, after all, it changes with each new generation, each publishing season, and each technological innovation. Whatever rules there are, someone is busy breaking them. The only sure question is: *Does the book succeed on its own terms for its own readers? Does the reader make the journey from cover to cover, or toss it aside and never return?*

The intention of this book is to show a broad range of examples in order to expand your options and help you to make your own choices. Certain creative solutions and methods may serve as models for you; others may seem less effective. Some tools you'll pick up and some you'll discard. But the majority of suggestions and insights will come directly from the practitioners themselves: more than 50 widely published and highly acclaimed writers, illustrators, editors, art directors, publishers, designers, teachers, and critics from nearly every corner of the globe.

The first section, The Picture Book, introduces basic picture-book concepts and vocabulary. Art and Craft explores the building blocks of children's illustration, and Storytelling brings those ideas into the realm of the story. Traditional Tools and Digital Dreams present an array of traditional and digital media techniques, and Multiple Markets offers a selection of additional avenues to pursue.

Finally, of the many principles discussed throughout this book, the most important—so essential that it underlies the rest—is *unity*. This is the sense of oneness, of harmony, that few picture-book authors achieve but all seem to aspire to. Unity means that every single element of a picture book—words, lines,

Children's literature is open to all...

shapes, colors, space, frames, and so on—work together to produce a purposeful order. Unity in design and literature (the twin domains of the picture book) is not sameness or lack of variation, but a marshaling of forces that connect, coordinate, and cooperate to create a total emotional effect. It could be wonder or laughter, a glimmer of hope, or a shiver of fear. Whatever it is, when a child finds it, he or she might just carry that feeling forever.

The right book in the right hands at the right time can shape a life, so being a picture-book author or illustrator is a tremendous responsibility. It is also, as the artists featured in this book can affirm, a source of profound happiness.

The Picture Book

A picture-book timeline

More than 350 years of what we now call children's picture books have shown us that there is no single story, no neat chronology, that encapsulates this multifaceted, world-spanning art form. However, certain events have contributed to the loose chain of cause and effect that represents the history of children's literature—at least in Western Europe and North America. The timeline below is merely a small collection of pivotal points on that timeline; anything more is beyond the scope of this book. For recommended reading, see pages 184-185.

Seventeenth century

1658: Czech educator Johannes Amos Comenius publishes *Orbis Sensualium Pictus* (*The Visible World in Pictures*), widely considered the first children's picture book.

1697: Charles Perrault publishes *Tales and Stories of the Past with Morals.*

Eighteenth century

1744: London bookseller John Newbery publishes *A Little Pretty Pocket-Book.*

1789: William Blake publishes *Songs of Innocence.* It was then published together with *Songs of Experience* in 1794.

Nineteenth century

1812: Jacob and Wilhelm Grimm publish what is now known as *Grimm's Fairy Tales.*

1835: Hans Christian Andersen begins to publish his original fairy tales.

1838: George Cruikshank illustrates Charles Dickens' *Oliver Twist.*

1845: Heinrich Hoffmann publishes *Der Struwwelpeter* (Slovenly Peter).

1846: Edward Lear publishes *A Book of Nonsense.*

1864: Walter Crane first collaborates on children's books with color printer Edmund Evans.

1865: Lewis Carroll and John Tenniel publish *Alice's Adventures in Wonderland.*

1878: Randolph Caldecott illustrates William Cowper's *The Diverting History of John Gilpin.*

1883: Howard Pyle publishes *The Merry Adventures of Robin Hood.*

1888: Kate Greenaway illustrates Robert Browning's *The Pied Piper of Hamelin.*

1893: The New York Public Library establishes the first Children's Room.

1897: L. Leslie Brooke illustrates Andrew Lang's *Nursery Rhyme Book.*

1899: Helen Bannerman publishes *The Story of Little Black Sambo.*

Twentieth century

The 1900s

1900: L. Frank Baum and W. W. Denslow publish *The Wonderful Wizard of Oz*.

1902: Beatrix Potter publishes *The Tale of Peter Rabbit*.

1904: Maxfield Parrish illustrates Eugene Field's *Poems of Childhood*.

1906: Arthur Rackham illustrates James M. Barrie's *Peter Pan in Kensington Gardens*.

1907: Edmund Dulac illustrates *Stories from The Arabian Nights*.

The 1910s

1911: N.C. Wyeth illustrates Robert Louis Stevenson's *Treasure Island* (1883).

1914: Kay Nielsen illustrates *East of the Sun and West of the Moon*.

1916: Bertha Mahony opens The Bookshop for Boys and Girls in Boston, USA.

1916: Jessie Wilcox Smith illustrates Charles Kingsley's *The Water Babies* (1863).

1919: Louise Seaman Bechtel establishes the first juvenile book department at the Macmillan Publishing Company.

The 1920s

1920: Hugh Lofting publishes *The Story of Doctor Dolittle*.

1921: Lucy Sprague Mitchell publishes *Here and Now Story Book*.

1921: Frederic G. Melcher establishes the John Newbery Medal in the US.

1922: Margery Williams and William Nicholson publish *The Velveteen Rabbit*.

1923: C.B. Falls publishes *ABC Book*.

1924: Bertha Mahony Miller launches *The Horn Book Magazine*.

1925: Attilio Mussino illustrates Carlo Collodi's *The Adventures of Pinocchio* (1883).

1926: E. H. Shepard illustrates A. A. Milne's *Winnie-the-Pooh*.

1928: Wanda Gág publishes *Millions of Cats*.

1929: Hergé (Georges Remi) begins publishing *The Adventures of Tintin*.

The 1930s

1930: Edward Steichen publishes *The First Picture Book: Everyday Things for Babies*.

1930: Marjorie Flack publishes *Angus and the Ducks*.

1931: E.H. Shepard illustrates Kenneth Grahame's *The Wind in the Willows* (1908).

1931: Jean de Brunhoff creates *The Story of Babar*.

1932: Lois Lenski publishes *The Little Family*.

1932: Lewis W. Hine publishes *Men at Work*.

1933: Wanda Gág publishes *The ABC Bunny*.

1933: Marjorie Flack and Kurt Wiese publish *The Story About Ping*.

1936: Edward Ardizzone publishes *Little Tim and the Brave Sea Captain*.

1936: Munro Leaf and Robert Lawson publish *The Story of Ferdinand*.

1937: Dr. Seuss publishes *And to Think That I Saw it on Mulberry Street*.

1938: Claire Huchet Bishop and Kurt Wiese publish *The Five Chinese Brothers*.

1938: First Randolph Caldecott Medal awarded to Dorothy P. Lathrop's *Animals of the Bible*.

1938: Esphyr Slobodkina publishes *Caps for Sale*.

1938: Jerry Siegel and Joe Shuster's Superman first appears in *Action Comics #1*.

1939: Ludwig Bemelmans publishes *Madeline*.

1939: Virginia Lee Burton publishes *Mike Mulligan and His Steam Shovel*.

The 1940s

1940: Dorothy Kunhardt publishes *Pat the Bunny*.

1941: Margaret and H.A. Rey publish *Curious George*.

1941: Robert McCloskey publishes *Make Way for Ducklings*.

1942: Margaret Wise Brown and Clement Hurd publish *The Runaway Bunny*.

The 1960s

1961: Quentin Blake illustrates Roald Dahl's *James and the Giant Peach.*

1962: Maurice Sendak publishes *The Nutshell Library.*

1962: Brian Wildsmith publishes his *ABC.*

1962: Ezra Jack Keats publishes *The Snowy Day.*

1963: Maurice Sendak publishes *Where the Wild Things Are.*

1963: Richard Scarry publishes his *Best Word Book Ever.*

1966: Evaline Ness publishes *Sam, Bangs & Moonshine.*

1966: The Hans Christian Andersen Award for Illustration is established.

1967: Bill Martin, Jr. and Eric Carle publish *Brown Bear, Brown Bear, What Do You See?*

1967: Charles Keeping publishes *Charley, Charlotte and the Golden Canary.*

1967: Biennial of Illustration Bratislava (BIB) award is established.

1968: Pat Hutchins publishes *Rosie's Walk.*

1968: Leo Lionni publishes *Swimmy.*

1969: Eric Carle publishes *The Very Hungry Caterpillar.*

1969: John Steptoe publishes *Stevie.*

1969: William Steig publishes *Sylvester and the Magic Pebble.*

The 1970s

1970: Maurice Sendak publishes *In the Night Kitchen.*

1970: Arnold Lobel publishes *Frog and Toad Are Friends.*

1971: Tana Hoban publishes *Look Again!*

1972: Judith Viorst and Ray Cruz publish *Alexander and the Terrible, Horrible, No Good, Very Bad Day.*

1972: James Marshall publishes *George and Martha.*

1973: David Macaulay publishes *Cathedral.*

1974: Gerald McDermott publishes *Arrow to the Sun.*

1975: Mitsumasa Anno publishes *Anno's Alphabet.*

1975: Tomie dePaola publishes *Strega Nona.*

1975: Leo and Diane Dillon illustrate Verna Aardema's *Why Mosquitoes Buzz in People's Ears.*

1978: Donald Crews publishes *Freight Train.*

1942: Virginia Lee Burton publishes *The Little House.*

1942: Simon & Schuster launches Little Golden Books line including Janette Sebring Lowrey and Gustaf Tenggren's *The Poky Little Puppy.*

1945: Ruth Krauss and Crockett Johnson publish *The Carrot Seed.*

1945: Tove Jansson publishes *The Moomins and the Great Flood.*

1945: Garth Williams illustrates E. B. White's *Stuart Little.*

1945: Maud and Miska Petersham publish *The Rooster Crows.*

1946: Margaret Wise Brown and Leonard Weisgard publish *The Little Island.*

1946: Osamu Tezuka publishes *New Treasure Island* in Japan.

1947: Margaret Wise Brown and Clement Hurd publish *Goodnight Moon.*

1947: Roger Duvoisin illustrates Alvin Tresselt's *White Snow, Bright Snow.*

The 1950s

1952: Garth Williams illustrates E. B. White's *Charlotte's Web.*

1952: Lynd Ward publishes *The Biggest Bear.*

1953: Morton Schindel's Weston Woods Studios begins producing picture-book films.

1953: Jella Lepman founds the International Board on Books for Young People (IBBY).

1954: Marcia Brown publishes *Cinderella, or the Little Glass Slipper.*

1955: Crockett Johnson publishes *Harold and the Purple Crayon.*

1955: The Kate Greenaway Medal for Illustrators is established in the UK.

1956: Gene Zion and Margaret Bloy Graham publish *Harry the Dirty Dog.*

1957: Dr. Seuss publishes *The Cat in the Hat.*

1957: Else Holmelund Minarik and Maurice Sendak's *Little Bear* launches the HarperCollins "I Can Read" series.

1957: Tomi Ungerer publishes *The Mellops Go Flying.*

1958: Barbara Cooney publishes *Chanticleer and the Fox.*

1959: René Goscinny and Albert Uderzo begin publishing *The Adventures of Asterix.*

1979: Chris Van Allsburg publishes *The Garden of Abdul Gasazi*.

1979: Rosemary Wells publishes *Max's First Word*.

1979: Coretta Scott King Awards expand to recognize African-American authors and illustrators.

The 1980s

1980: Toshi Maruki publishes *Hiroshima No Pika*.

1981: Maurice Sendak publishes *Outside Over There*.

1981: Alice and Martin Provensen illustrate Nancy Willard's *A Visit to William Blake's Inn*.

1981: Chris Van Allsburg publishes *Jumanji*.

1983: Anthony Browne publishes *Gorilla*.

1984: Trina Schart Hyman publishes *Saint George and the Dragon*.

1985: Chris Van Allsburg publishes *The Polar Express*.

1987: Julius Lester and Jerry Pinkney publish *The Tales of Uncle Remus*.

1989: Bill Martin Jr., John Archambault, and Lois Ehlert publish *Chicka Chicka Boom Boom*.

1989: John Scieszka and Lane Smith publish *The True Story of the 3 Little Pigs*.

1989: Michael Rosen and Helen Oxenbury publish *We're Going on a Bear Hunt*.

1989: Ed Young publishes *Lon Po Po: A Red-Riding Hood Story from China*.

The 1990s

1990: David Macaulay publishes *Black and White*.

1991: David Wiesner publishes *Tuesday*.

1993: Maurice Sendak publishes *We Are All in the Dumps with Jack and Guy*.

1993: J.otto Seibold and Vivian Walsh publish *Mr. Lunch Takes a Plane Ride*.

1993: Allen Say publishes *Grandfather's Journey*.

1994: Eve Bunting and David Diaz publish *Smoky Night*.

1995: Peggy Rathmann publishes *Officer Buckle and Gloria*.

1996: Peter Sís publishes *Starry Messenger: Galileo Galilei*.

1996: David Wisniewski publishes *Golem*.

1997: Paul O. Zelinsky publishes *Rapunzel*.

1998: Jacqueline Briggs and Mary Azarian publish *Snowflake Bentley*.

1999: Simms Taback publishes *Joseph Had a Little Overcoat*.

Twenty-first century

2000: Judith St. George and David Small publish *So You Want to Be President?*

2001: David Wiesner publishes *The Three Pigs*.

2002: The Eric Carle Museum of Picture Book Art opens in Amherst, Massachusetts.

2002: Gennady Spirin publishes *The Tale of the Firebird*.

2003: Maurice Sendak and Tony Kushner publish *Brundibar*.

2003: Mordicai Gerstein publishes *The Man Who Walked Between the Towers*.

2003: Sara Fanelli illustrates Carlo Collodi's *Pinocchio*.

2004: Kevin Henkes publishes *Kitten's First Full Moon*.

2005: Norton Juster and Chris Raschka publish *The Hello, Goodbye Window*.

2006: David Wiesner publishes *Flotsam*.

2007: Brian Selznick publishes *The Invention of Hugo Cabret*.

2008: Susan Marie Swanson and Beth Krommes publish *The House in the Night*.

Illustration by Lesley Breen Withrow.

Defining form and format

Form is a set of descriptive ideas about format, medium, content, genre, audience, structure, and style—all of which will be explored throughout this book. As the preceding pages show, the picture-book form has been evolving for more than 350 years, and with each new generation, artists and critics are continually redrawing the form's boundary lines. In other words, defining the picture book form is like aiming at a moving target. The best we can do is to take part in the global conversation through our words and our own work.

Format is the object that results when a writer, illustrator, designer, editor, art director, or publisher applies his or her ideas about form. "Format" is what we generally mean when we say "form"—the finished products we purchase in bookstores or borrow from libraries. There we find numerous groupings

based on length, size, shape, primary age group, "read-aloud" or "read-alone" capacity, genre (e.g., fiction or nonfiction), word/picture balance, sophistication of content and vocabulary, and instructional value, among other criteria.

Today's picture-book formats span across multiple media (e.g., print, digital, audiovisual, or handmade) and are tied closely to the technology that produced them. For example, the common 32-page picture-book format developed because, in offset printing, a book's pages are arranged in multiples of 32 or 16 pages per press sheet, depending on trim size. When the press sheet is folded, the pages are aligned in numerical order. Each multiple of 32 or 16 is referred to as a signature.

In *A Picture Book Primer,* Denise I. Matulka identifies four classifications: picture books (short picture-driven narratives); picture storybooks (where text and pictures contribute more or less equally to the narrative); illustrated books (longer text-driven narratives with supporting pictures); and informational picture books (a subset of the "picture book" format that includes "concept" books). As useful as these terms are, we have decided to be more inclusive in our discussion and have applied the term "picture book" to various individual works (such as a wordless graphic novel) that do not fit neatly into any one category.

1. Self-promotional piece, © by Charlene Chua. The artist comments playfully on the power of the book format to contain and release imaginative content.

Form is a set of ideas; format is the object that results...

Bridget Strevens-Marzo on the picture book

There is a lot of cultural baggage around the term "picture book." In the US and UK there is an "ideal" picture-book format. It is 32 pages long, and a perfect interlocking between words and pictures. It gets most of the prizes in the children's book world, most of the attention, and spills the most ink. There are some great works in this format and they deserve attention, but the format originated in the twentieth century, and many illustrated books made for children today don't quite fit this mold.

I like to think of the term "picture book" as being more open-ended—it's shorthand for an illustrated book that tends to be for children (although some are probably more appreciated by art students!). A picture book can tell one or many stories, with or without words, and may even have not so much a story as a thread that takes us into a succession of worlds we can play around in.

The crucial word that makes picture books different from other narrative art is "book," and from that comes "page turn." The book sits on the shelf, offering you the power to make it move. When you put the book down, you close off its world. It's a kind of intimate power-sharing; each time you turn a page, you enter a different space or time. In comic-book art this happens from frame to frame, but in both cases, more or less consciously, an idea of a totality builds up, which is more than the sum of each page. (See pages 138–141 for more information.)

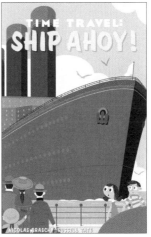

2. In this illustration from *Aron the Artist*, which pokes gentle fun at "fine art," the abstract form of the background painting is echoed by the two-dimensionality of the foreground figures. © 2009 by Russell Tate.

3. *Time Travel: Ship Ahoy!* is an example of a mixed-media format, containing both a printed book and an accompanying CD. © 2009 by Russell Tate.

Style, genre, and audience

The business of children's illustration can be boiled down to the process of creating a *style* that is appealing in a *genre* that is selling to a growing *audience*. This doesn't begin to define the art of children's illustration; however, for the purposes of marketing one's work to publishers, there are worse blueprints for success.

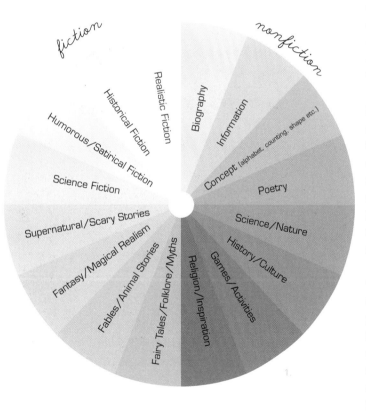

fiction

nonfiction

Realistic Fiction
Historical Fiction
Humorous/Satirical Fiction
Science Fiction
Supernatural/Scary Stories
Fantasy/Magical Realism
Fables/Animal Stories
Fairy Tales/Folklore/Myths
Religion/Inspiration
Games/Activities
History/Culture
Science/Nature
Poetry
Concept (alphabet, counting, shape etc.)
Information
Biography

1.

Style, which goes beyond the surface look of a drawing, is the total effect of an artist's craft and sensibility combined. This can vary greatly between projects, but reviewers often point out certain signature features of an individual's work—a particular line quality, color palette, page layout, etc.—that recur over time and form something of a unified aesthetic. Depending on our knowledge of art history and theory, we might label such characteristics as realistic or abstract, cartoonish or surreal, impressionistic or expressionistic, and a host of other terms. Ultimately, though, it is a subjective choice for both the creator and the critic.

If style is a description of how an artist communicates, then content is a summary of all that is communicated—style is the approach; content is the material. In terms of its content, a picture book generally falls into one of two basic categories or genres: fiction and nonfiction. Fiction is an invention for telling a story that may or may not draw upon accepted facts. Nonfiction is a structure for conveying factual and conceptual information that may or may not tell a story. (See left for a selection of subgenres and hybrids.)

When we say two fiction books are in the same genre, we are recognizing a shared set of conventions—common story patterns, narrative devices, character types, and settings—that expand our appreciation and understanding of a story by comparing and contrasting it with other similar and dissimilar stories. The line between genre and rote formula is easily crossed, it should be noted, and the most enduring picture books are often those that combine genres in unexpected ways.

1. A "genre wheel" showing common categories of fiction and nonfiction picture books.

2. Wraparound cover art for an in-progress board book, typically aimed at very young readers, by Liz Goulet Dubois.

Even thornier than defining style and genre is prescribing for whom a specific picture book is and isn't suited; in other words, the very grown-up task of targeting groups of readers based on gender, age group, nationality, ethnicity, reading readiness, frame of reference, and comprehension level. Certainly, children's book publishers expend enormous energy in the pursuit of the most profitable demographics, while many teachers, librarians, and parents have historically railed against "inappropriate" material for children and teens. Real controversy still surrounds these matters (see pages 184–185 for further reading material).

Meanwhile, picture-book artists—in much of the world, anyway— are free to choose their style, content, genre, and perhaps even their audience. Demographic data and educational theory aside, there are no absolute right answers in business or in art, and how you go about exercising that freedom is up to you.

3. Page from the "all-ages" graphic novel and webcomic *The Dreamland Chronicles* by Scott Christian Sava.

4. Image from *Time Travel: Ship Ahoy!* by Russell Tate, which bridges elements of historical fiction, science fiction, fantasy, and informational nonfiction.

Communicating across cultures

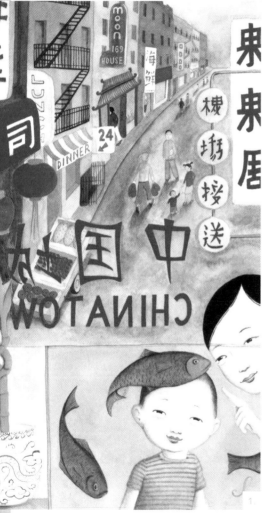

Multiculturalism and internationalism might seem like incongruously grown-up terms for the world of children's picture books, yet throughout the history of the form, writers, artists, and publishers have built enduring bridges between and among nations and cultures. Many picture-book creators have challenged prejudices and preconceptions through their work while championing individual identity and a sense of belonging for all—not for reasons of political correctness, but to share a genuine love of diversity and commonality.

When communicating within a culture or across different cultures, factual and emotional accuracy is essential, and this often requires rigorous research. Cheryl Kirk Noll, who specializes in illustrating historic and multicultural books (see pages 66–69), says, "When I depict cultures or time periods, I feel a responsibility to be as accurate as possible. I begin my research on the Internet, focusing on sites that I know are reliable. Then I head for the library, which I still find is the best place to get in-depth information. City and college libraries offer the best selection, and I often settle myself in for a good afternoon of searching the stacks."

Noll also keeps an extensive home library and picture file where she saves sketches, photos of models, pictures from magazines and the Internet, fabrics, and costumes that she has collected. She often uses visual reference books on subjects such as textiles, architecture, art, travel, photography, and costume. Genre painting is also a favorite resource. She will sometimes watch movies of the culture or time period, but reviews carefully whether they have been well researched.

1. Chinatown image, © by Sophie Blackall.

2. Cover of *Fatuma's New Cloth*, written by Leslie Bulion and illustrated by Nicole Tadgell, © by Nicole Tadgell.

Research trips and expert interviews are equally valuable tools for the picture-book author. Trips can range from around the world to just down the road. "Experts" can mean specialists or academics able to offer new sources of information and to check facts, or simply regular people willing to tell family stories and share unique customs and experiences.

"I believe that people everywhere want the same things… community, love, safety, family," says Noll. "No matter what their culture, I see human beings expressing themselves through art, dance, and music. I feel blessed that I am able to not only make a living through my art, but that I also get to explore the multitude of ways used by cultures around the world to express universal needs and desires."

Nicole Tadgell on multiculturalism

Illustrator Nicole Tadgell's many picture books tell stories that involve cultural themes. "It's odd for me when people refer to Black culture or Asian culture or Hispanic culture," she says. "Sure, there are aspects and similarities, sort of like subcultures of American culture. It's true that people with similar traits or experiences tend to feel comfortable with each other—high-school cliques come to mind. But there isn't just one way to be. There are so many different experiences, and they are all valuable. I think multiculturalism is the attempt to share those experiences.

"People look at my work and say, 'Wow! Your characters look like real people.' Most of them aren't models—I make up people based on aspects of real people I've observed. When I draw, I think of each person as having a full life before I drew them, and they'll have a full life after. What are they thinking? Did she just scold her son earlier? Is that man thinking of what he might be having for lunch later, or did he just realize that he mismatched his socks? It's the human experience that I see and draw—not colors or cultures."

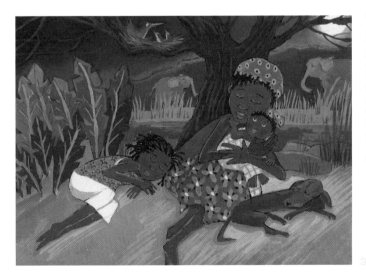

3. Illustration of an African family sleeping, © 2009 by Nancy Cote.

Balancing words and pictures

Picture books offer a wide spectrum of relationships between words and pictures—from books without words to books where words and pictures are completely interchangeable. Even within a single book, the word–picture relationship can vary from page to page. In *A Picture Book Primer*, Denise I. Matulka identifies three basic relationships: symmetrical, complementary, and contradictory. We also consider the different degrees of integration or interdependence between words and pictures.

Symmetrical

A symmetrical relationship is a redundant (more or less equal) pairing of words and pictures. In effect, they both say virtually the same thing—remove one or the other and you still get the message. In general, this type of relationship is the least interdependent or integrated, and words are often set apart from the pictures using negative space or a definite border of some sort. The direct reinforcement of the meaning of words through pictures can be an effective tool in teaching children how to read.

Complementary

A complementary relationship is usually more interdependent and integrated than a symmetrical one. Words and pictures add to or amplify one another. There is also a less distinct visual divide between the two. This type of relationship typically requires more interaction on the part of the reader to complete the story that both the words and pictures are telling. Some complementary pairings are read in counterpoint, one before the other (see image 2), whereas in the visual language of comics, words and pictures are more integrated and can be read simultaneously (see image 3).

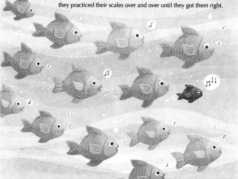

1. Symmetrical spread from *Time Travel: When in Rome*, © 2009 by Russell Tate.

2. Complementary "scales" page by Lesley Breen Withrow.

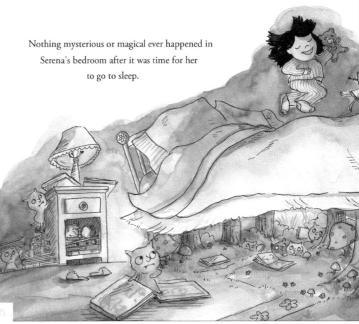

Nothing mysterious or magical ever happened in Serena's bedroom after it was time for her to go to sleep.

Contradictory

A contradictory relationship, where words and pictures say the opposite, can be used to build suspense or communicate irony, which calls attention to the incongruity between what the character perceives and what the reader sees on the page. Contradictory and ironic pairings often require a high level of reader interaction.

Concrete poetry

Betsy Franco, poet and author of *A Curious Collection of Cats* (illustrated by Michael Wertz), says, "Concrete/visual poetry is a beautiful integration of text and illustration because the words themselves create a picture that reflects their meaning. For example, the words can be positioned to reflect the action described in the poem. In a picture book, the pictures illustrate the words; in a concrete poem, the words participate in the illustration."

3. Comic strip from *Sticky Burr*, written and drawn by John Lechner. © 2009 by John Lechner.

4. An onomatopoeic page, where the words imitate the sounds they describe, by Lesley Breen Withrow.

5. Ironic spread by Lesley Breen Withrow.

Expert commentary:
Leonard S. Marcus

Leonard S. Marcus is regarded as one of the most respected and versatile writers, historians, critics, and speakers in the children's book world. His highly acclaimed books include Margaret Wise Brown: Awakened by the Moon; Dear Genius: The Letters of Ursula Nordstrom; A Caldecott Celebration; Author Talk; Side by Side; Ways of Telling; Storied City; The Wand in the Word: Conversations with Writers of Fantasy; Pass It Down; Golden Legacy; Minders of Make-Believe: Idealists, Entrepreneurs, and the Shaping of American Children's Literature; *and* Funny Business: Conversations with Writers of Comedy. *His incisive book reviews have been featured in every issue of* Parenting *magazine since its launch in 1987, and he is a frequent contributor to* The New York Times Book Review, The Washington Post Book World, The Horn Book, *and* Publishers Weekly, *among other publications. He and his wife, the picture-book artist Amy Schwartz, live with their son Jacob in Brooklyn, New York.*

How do you define a "picture book"?

A picture book is a type of book where the illustrations and text organically relate to one another, contributing more or less equally to the total experience. Most picture books these days are 32 pages, but this form is not quite as fixed as that for, say, a sonnet. Still, picture books are generally short. They are also highly distilled artworks and, I would say, a restless form, in which rhythm and pace play a more than incidental role, and in which the art tends to lend itself toward the condition of animation. A picture book can be wordless, but in these cases the artist has to set things up in such a way as to encourage readers to create their own narrative or account of what they see.

How would you characterize the quality of picture books currently being published in the USA and internationally in relation to those published in the past?

We are currently experiencing the time of the "almost good" book in the USA: picture books with highly accomplished (occasionally soulless) art and (very often) with weak text and little or no sense of inevitability driving them. For instance, trim sizes have tended to become bigger, but this is more in response to the need to stand out in a retail environment—it's a sales and marketing consideration rather than because the book needs to be big to tell its story in the best possible way. A different kind of talent is recognized now than was the case 50 years ago. In the past, an author or illustrator's first book tended to be a quiet, small, unpretentious apprenticeship piece. First books are now more likely to be technically polished and focus on a character that the publisher has detected as a possible basis for a series—the next Curious George. More talent has entered the field than ever before, and the career of the picture-book artist has more cachet at art schools than in past generations, but the end product—the book—often disappoints. They're what a teacher of mine once called "straw fires"—they burn brightly, but then quickly burn out.

Photograph by Sonya Sones.

Illustration and text relate organically...

It's hard to generalize about the rest of the world. Most books from European publishers that I saw at the 2008 Bologna International Children's Book Fair would not find a publisher here in the USA. European books tend to be less character-driven and more about design, although I have seen a number of recent memorable French picture books (not to mention comics and graphic novels). What many of these books have in common is a gutsiness and a lack of squeamishness about explosive feelings and danger; this is something that I associate with the picture books of Tomi Ungerer, who was never as popular as he might have been in the USA for that very reason.

In Japan you see some charming picture books that show the influence of mid-twentieth-century American picture-book artists like Marie Hall Ets and Don Freeman. These books are more humble, and radiate a feeling of intimacy that I think has been key to the long-lived popularity of many early American books. South Korea is in many ways the "new" Japan, and some interesting picture books are coming from there.

How important a role does the critic or reviewer play in children's literature?

As the retail side of the market for children's books has grown in the past 30 years, the critic's role has also increased. The people who buy books often go into the experience not knowing what they are looking for, and so they need guidance from others with that knowledge. Under these circumstances, it's interesting that the media have not exactly risen to the challenge. The understandable reluctance of children's book publishers to spend great sums on advertising has a lot to do with this, but what about the media's responsibility to the culture it serves? The web presents a much-needed forum and opportunity in this regard, and although blogs vary greatly in quality, this kind of problem will no doubt sort itself out with time.

In an environment of conglomerate publishing, discount retailers, and little funding for schools and libraries, do you feel that smaller, independent publishers can play a significant role in the field?

I think the smaller companies represent the future of publishing. Conglomerate publishing is, for the most part, highly inefficient, and it may be for that reason that they are shrinking in terms of their power within the market. Some of the most interesting smaller publishers in operation are Candlewick Press (which is not so small any more) and Roaring Brook Press. Within Roaring Brook, Mark Siegel's First Second Books imprint of graphic novels has already built up an extraordinary list. Toon Books, founded by Françoise Mouly and Art Spiegelman, is a fascinating attempt to adapt comic book-style storytelling to the needs and interests of emerging readers. I continue to admire Kane/Miller for its commitment to internationalism as a publisher of picture books.

Art and Craft

Composing the page

The underlying structure of any children's picture book becomes readily apparent once the surface elements of text and picture are stripped away, revealing the form's two most fundamental structural units: the single page and the double-page spread.

When composing the page and spread, all the time-tested rules of graphic design and two-dimensional art still apply, but added to them are the principles of visual narrative.

Here we examine a small selection of compositional ideas that are common to nearly all picture-book art. As simple as the images may seem, they reflect some of the primary ways picture-book artists convey meaning and emotion. One of the best books we have found on the subject of composition is *Picture This: How Pictures Work* by Molly Bang. We created these images based on some of the principles Bang introduces.

1. Readers associate flat horizontal shapes with calmness and stability.

2. Vertical shapes generate activity and energy.

3. Where horizontals meet verticals, stability is restored.

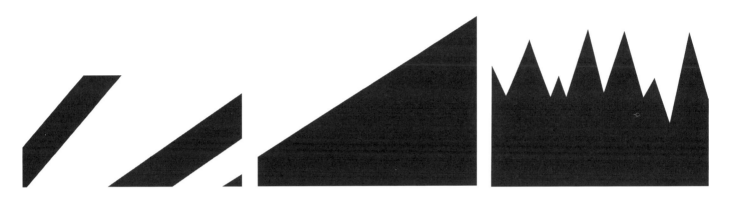

4. "Falling" diagonal shapes imply motion or tension.

5. We tend to "read" diagonals from left to right or right to left depending on our culture's reading order.

6. Pointed shapes can evoke a sense of fear.

7. Curved shapes can evoke a sense of comfort.

8. Negative space can be used to isolate or group figures.

9. Depth is created by "receding" figures through precise arrangement in space and through contrast in size, color, and/or value. This creates the effect of foreground, middle ground, and background.

Composition at work

From first page to last, a picture book sets up a dominant pattern of visual elements—lines, shapes, colors, etc.—which is akin to the metrical pattern in poetry or the rhythmic pattern in music. A unified picture book is a progression of like and unlike components, and any variations in that underlying pattern give a picture book its distinctive visual rhythm. Here author-illustrator Nancy Cote (see pages 70–71) shares her insights on how she composed three different spreads.

Henry and the Giant Tornado

Henry (the dog) and the farm animals are digging a hole for a shelter to save themselves from a giant tornado that is heading straight for the farm. The composition of this double-page spread is broken into quarters. The lower left quarter (green grass) is free space reserved for text placement. The action (beginning on the upper left side of the page) of the farmer and his wife running toward the animals sets up a composition that reads from left to right as the eye moves across the page to the approaching tornado and finally to the animals at the bottom of the page. The arch created by the shape of the landscape helps to achieve the movement culminating on the focal point at the bottom right, where the main action of the story is taking place.

A Perfect Angel (interior scene)

The composition of this interior double-page spread, if seen abstractly, is almost a mirror image. The shape of the hutch on the left of the page is echoed by the shape of the wall and table combined on the right. The window is centrally placed, which balances the two sides. Because of this abstract symmetry, Little Beaver, who breaks the symmetrical pattern, becomes a focal point and the eye gravitates toward his activity as he is seen struggling to reach for the ingredients he needs to make cookies. With the cooking ingredients out of reach, the reader is set up to feel the conflict created by being small

1. Scene from *Henry and the Giant Tornado*.

2–3. Scenes from *A Perfect Angel*. Illustrations © by Nancy Cote.

in a big world. Adventure is just a page turn away, as this composition sets up a problem in need of a solution. The frontal composition is constructed so that the reader can feel close to the activity. I created this kitchen scene so that you could enter it not only as an observer but as a participant sitting at the table watching Little Beaver's actions, therefore identifying more intimately with the main character.

A Perfect Angel (exterior scene)

Little Beaver tries to find the perfect gift for his mama. He knows that she loves flowers, so he goes outdoors to search for some. Being winter, all he finds outside is snow. He makes several unsuccessful attempts at coming up with a perfect gift only to discover that the most simple one is right at his fingertips. I have basically divided this double-page spread in half. The left half leaves a wide area on the icy pond open for the placement of text. The right half illustrates who Little Beaver is, where he lives, what time of year it is, and it shows his emotional dilemma. The circular movement of the snowy landscape is emphasized by the swirling snow that winds itself around the main character. The warm colors that Little Beaver is composed of allow the eye to focus on him, while the cooler blue tones of the landscape recede. Movement is the primary element this composition is based on—it directs the viewer around the page.

> *A picture book is a progression of like and unlike components.*

Working with color

Before the advent of modern printing technology, picture-book illustrators were forced to master black-and-white or limited-color compositions. While monochrome art still plays a role in some books, today's illustrators can take advantage of a nearly limitless array of colors. Choosing a unified, expressive color palette for a book has become a prerequisite for success.

The three fundamental aspects of a color are its hue, value, and saturation. Each aspect contributes to the symbolic and emotional significance of that color.

Hue

The color property of hue refers to a pure color such as red, yellow, or blue without tint or shade (white or black added, respectively). There are primary, secondary, and tertiary hues, which can be described as warm or cool, complementary or contrasting.

Generally, warm colors seem to advance toward the reader and cool colors seem to recede, so cool colors such as blue and green are often used for backgrounds and warm colors such as red and yellow for focal points. There are also cool reds and yellows and warm blues and greens, depending on how the colors are mixed.

Complementary colors (opposites on the color wheel) are great to blend because they can create some wonderfully rich mixes. When complementary colors are juxtaposed, they each seem to pop off the page. For example, when blue is used with orange, the blue appears more blue and the orange appears more orange.

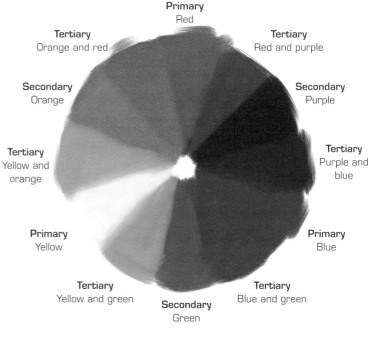

Primary
Red

Tertiary
Orange and red

Tertiary
Red and purple

Secondary
Orange

Secondary
Purple

Tertiary
Yellow and orange

Tertiary
Purple and blue

Primary
Yellow

Primary
Blue

Tertiary
Yellow and green

Tertiary
Blue and green

Secondary
Green

Warm Colors Cool Colors

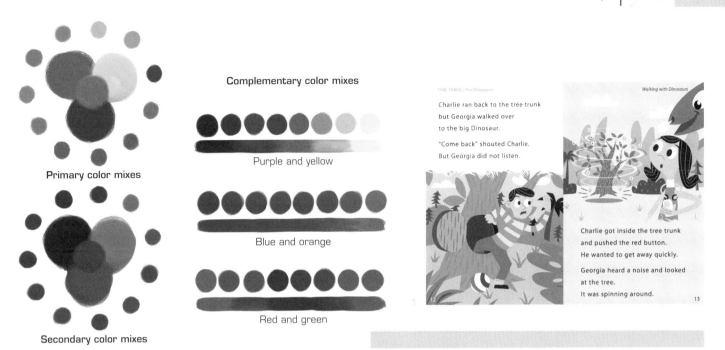

Primary color mixes

Secondary color mixes

Complementary color mixes

Purple and yellow

Blue and orange

Red and green

TIME TRAVEL: The Dinosaurs

Charlie ran back to the tree trunk
but Georgia walked over
to the big Dinosaur.

"Come back" shouted Charlie.
But Georgia did not listen.

Walking with Dinosaurs

Charlie got inside the tree trunk
and pushed the red button.
He wanted to get away quickly.

Georgia heard a noise and looked
at the tree.
It was spinning around.

Value and saturation

Value refers to the darkness (shade) or lightness (tint) of a hue. As noted above, adding white to a hue increases the tint, while adding black increases the shade. Saturation (also called intensity) is the brightness or paleness of a hue.

The purposeful interplay of value and saturation, along with hue, affects the mood of a drawing and the reader's emotional response to it. Also, individual colors can have a wide range of symbolic or elemental connotations (e.g., red for blood and fire, green for life and growth, and blue for water and peace). We should note that not all readers in all cultures will make the same symbolic connections, and many scholars say that young readers must learn, on some level, to recognize these color references. Colors achieve their unique meanings in relation to one another and in the context of the story being told.

Russell Tate on color in action

The idea behind *Time Travel: Dinosaurs* was to transport modern children to a place that was magical and very different from present-day reality. At the beginning and end of the book, I drew the children's real environment in shades of pink and very much underplayed the background of the scenes. Once they arrive in prehistoric times, everything is strange—the shapes of plants and trees and especially the colors used in the scene. I decided to use some bright, garish colors but to pair them with other, more subtle complementary shades—mainly tones of gray in order to avoid the whole book looking like an explosion in a paint factory! As the story had a certain dreamlike quality, I kept changing the color schemes from one age to the next: the tree might be purple with yellow leaves on one page and blue with pink leaves on the next. I kept the children and their clothing consistent throughout so that the reader could see they were real and not really part of the weird prehistoric world.

Distance and perspective

Before any art is created, the writer of a picture book needs to decide on the basic "narrative distance" for the story. First-person stories where the central character is the narrator are said to be the most intimate, allowing us, in some cases, to read the character's mind. Third-person stories told from a more detached viewpoint may hew closely to the character's experience and voice, or may be more objective and omniscient overviews.

Similarly, the illustrator can affect the reader's response to characters and events by manipulating the proximity and angle between observer (the reader) and object (the picture). Simply put, the closer we are, and the better we see, the more we care.

To borrow another set of metaphors, an illustrator, like a film director, can position and focus the "camera" (i.e., the reader's vantage point) wherever it best conveys the necessary visual information or captures the intended emotional effect of the scene. Even a simple change such as raising or lowering the horizon line on a page can have important storytelling ramifications. (See Anne Sibley O'Brien's discussion of theatrical and cinematic perspective on pages 54–55.)

Size and placement are key to linear perspective. Objects are drawn smaller as their distance from the observer increases. For straight-on or low-angle shots, the lower part of the page or panel is generally the foreground, and the higher you move on the page, the more the objects recede into the background. (Conversely, for certain higher angles, such as a "helicopter shot" of a skyscraper with its roofline projecting toward the viewer as seen from above, the foreground or closest objects appear at the top of the page.) Also, many artists use

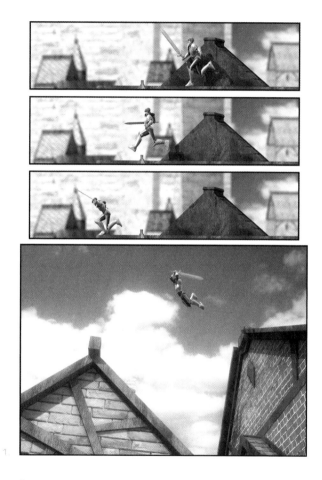

foreshortening—the optical illusion that an object or distance appears shorter than it actually is because it is angled toward the viewer—to enhance the sense of depth.

1. Cinematic angles on the action from *The Dreamland Chronicles* by Scott Christian Sava.

Jannie Ho on perspective in vector illustration

I once had a meeting with an art director who told me that
the problem with a lot of vector illustrations isn't that they are
digital, but that they are usually very flat in terms of perspective.
For this piece (right), I had a very slim vertical rectangle to work
with, which didn't allow me to put in the details I would have
if the perspective was flat. So I challenged myself in coming up
with something more dynamic. I thought the bee's point of view
would be interesting: what does it see below as it flies through
the air? Adding the tree with its shadows also helps emphasize
the perspective.

Russell Tate on drawing the Titanic

Time Travel: Ship Ahoy! was created to help children with
reading difficulties. To vary the pace and engage the reader,
I chose to vary the angle or viewpoint, sometimes up close and
other times way back. The previous page showed only a small
section of a door on the Titanic, so in this image I wanted to give
a sense of scale and reveal the ship's size. I brought the viewer
into the page from the left and down to the small characters at
the bottom of the page. I drew the characters from the back so
there was no interaction with their faces and we looked at what
they were looking at. Then, with greatly exaggerated perspective,
I enlarged the front of the ship, leading the reader's eye to the
page edge and encouraging the page turn.

Case study: Elusive Moose

Joan Gannij and Clare Beaton

Nominated in 2008 for the Kate Greenaway Medal (awarded by children's librarians for outstanding illustration in children's book publishing), *Elusive Moose*, written by Joan Gannij and illustrated by Clare Beaton, is a lyrical trip to northern lands in search of the elusive moose hidden in every scene of the book. Informative notes at the end help readers learn about different animals and the changing seasons.

According to Beaton, the publisher sent her Gannij's manuscript to illustrate because she had previously worked on other animal stories for them, and *Elusive Moose* followed a similar format.

The books Beaton illustrates for Barefoot Books are all fabric collage. "Each book primarily differs from others because of the colors I choose," she says. "In *Elusive Moose*, I decided to work through the seasons, starting in spring with light, fresh greens, and ending in winter with white, sparkly snow. With my most recent books, I have followed the look of the end papers in *Elusive Moose*, using white sheeting and linen as the backgrounds, which gives a fresh, clean look."

"I handsew the pictures using felt, vintage fabrics, buttons, braid, old jewelry, and sequins," she continues. "Old aprons are a particularly rich source for wonderful fabrics. I enjoy collecting my materials, and the recycling element appeals too. I'm always on the lookout for interesting things to use, and recently made

trees from nylon rope found on a beach. In my work, I like to give materials a new lease of life. I use only running stitch and overstitch. Everything is handstitched, which takes ages, but I really love it."

Speaking of the primary audience for the book, Beaton says, "Small children at home, school, or in the library— adults too, I hope. My books often have an animal hiding on the page, in this case the elusive moose! Children love looking and finding these elements. I also add a sign that a child has been in the scene, in among the animals, such as a dropped ribbon, a paper boat, and so on. I think it's important to include more than the basic storyline in the illustrations, and this encourages an interaction between the child and the book."

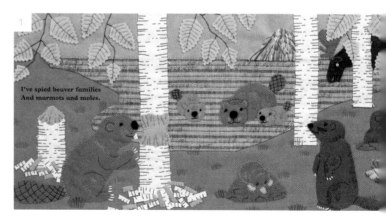

1–4. Four spreads from *Elusive Moose*, written by Joan Gannij and illustrated by Clare Beaton.

Clare Beaton, illustrator of *Elusive Moose*

Clare Beaton is a children's book writer and illustrator who works from her home in London, England. She studied graphics and illustration at art college, and not long afterward worked for the BBC as an illustrator for children's TV programs. She eventually left to go freelance and got her first commission to illustrate a book about a cat called Wilkins. She started illustrating in fabric collage after *The Felt Book*, one of scores of craft and activity books she has had published. She has also stitched a number of posters that can be seen at felixr.com.

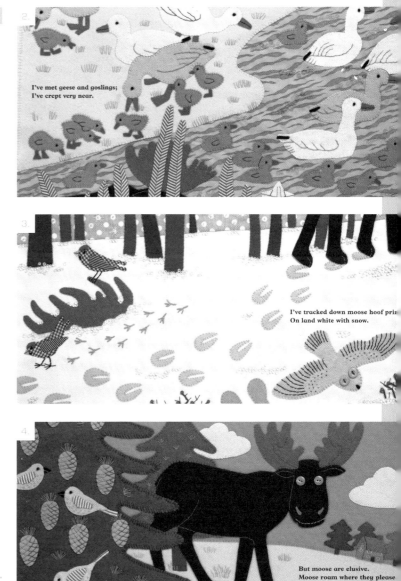

I've met geese and goslings;
I've crept very near.

I've tracked down moose hoof prin
On land white with snow.

But moose are elusive.
Moose roam where they please

I wish I could see one
Just once. May I, please?

Expert commentary:
Judy O'Malley

Judy O'Malley has been working in publishing for more than 30 years as an editor of children's trade books and magazines, professional books and magazines, and educational materials. Now a freelance editor and consultant, she was most recently the Executive Editor of trade books for Charlesbridge Publishing in Massachusetts, where she developed and directed new lines of transitional books, including early readers, early chapter books, and middle-grade chapter books. In her current freelance capacity, she works with different publishers on individual projects in a variety of genres and for different age groups, and also offers authors and illustrators guidance in shaping, developing, and targeting their manuscripts.

How do you define a "picture book"?

In concise terms, a picture book is a joint narrative expressed with words and pictures. I think the traditional understanding of a picture book—work for very young children (ages 4–7) with a brief text accompanied by illustrations—has shifted drastically in the past few decades, and continues to morph as new technologies and other illustrated genres, like graphic novels and comic books, influence the ways in which picture books adapt to suit new audiences. I see the picture book as a fluid format, open to innovation and experimentation by talented authors and illustrators who continue to expand the boundaries of what picture books can be.

More recently, we have seen many distinguished picture books with longer, more sophisticated stories intended for older readers. Defying expectations that picture books are 32 pages long, or occasionally 40 or 48 pages, the 2008 Randolph Caldecott Medal was awarded to *The Invention of Hugo Cabret*, written and illustrated by Brian Selznick. This 500-plus page novel for readers aged 9–13 combines an involved narrative, evocative black-and-white illustrations, and the cinematic effect of precisely choreographed page turns. Other picture books now combine spot art, graphic panels, and standard full-page illustrations or double-page spreads to meet the needs of a particular story.

What is the editor's role in children's picture-book publishing?

Editors at different publishing houses may play different roles. At publishers with large divisions devoted to books for young readers, several editors may work on a single book. The acquiring editor may guide the book through the initial stages of revision and the acquisition process, but then turn the text over to an associate or assistant editor for developmental work and line editing. There may be an in-house copyediting department that checks the text for grammatical correctness, consistency, and conformity to house style. At a small or mid-sized publisher, the acquiring editor often carries the book through every stage of the editorial process. Regardless of the size of the publisher, the acquiring editor usually works closely with the art department in shaping the visual style and design for the book and in selecting the illustrator (when the author is not also the illustrator). The

editor also participates in establishing a schedule for completing each stage of editorial, art, design, and production work. The editor may also contribute to the marketing, publicity, and sales staff's efforts to develop an effective promotional campaign for the book.

What are some of the essential qualities you look for in a successful picture-book submission, both in terms of text and art?

A compelling story that has a strong visual component is always at the heart of a picture book. This is true whether the work is fiction, nonfiction, or poetry. Readers must feel a connection with characters and with their experiences. Even in a fantasy, there must be a clear story arc and internal truth that pulls the reader into the tale. Effective art sometimes plays against the tone or style of the text, sometimes complements it, or sometimes includes details or hidden clues not directly alluded to in the narrative. There really is no neat formula for what makes a picture book work. The choices that the author, illustrator, editor, and art director make cooperatively ensure that the finished book realizes the visions of its creators.

What qualities do you look for in an artist's portfolio?

I'm interested in work that is original, that's not derivative, and that shows stylistic proficiency. Children's tastes and expectations in art and literature are often first set by the picture books that are read to them when they are very young.

They deserve illustrations that are accomplished, clever, and daring. In reviewing portfolios I'm also interested in an artist's range of styles and ability to depict different settings, time periods, and characters. If the artist concentrates on a particular medium or technique, I want to see how he or she brings a personal flair to that technique. Expressiveness is essential in portraying specific physical traits, whether characters are humans or animals. If appropriate to the text, I also look for the ability to depict humor through surprising compositions, unexpected details, or absurd juxtapositions. The artist must be able to interpret the story, not just decorate it.

What additional advice would you give to a new or aspiring picture-book writer or illustrator?

Children's book publishing is an extremely complex and competitive field. To be successful, a writer or illustrator needs to learn as much as possible about the industry, bring his or her work to the highest possible level, and determine that there is a market for that work before seeking publication. There are many resources available in print, online, and through groups and professional organizations, but the essential requirement in navigating the course to publication is a passion for creating picture books.

Storytelling

Developing a narrative

According to world-renowned author Jane Yolen, a story is, quite simply, "a tale told that has a beginning, middle, and an end." She says that the three most essential elements of any picture-book story are compression, child-centeredness, and lilting prose.

While the number of multichapter graphic novels for older readers is increasing, most picture books are, in terms of length and basic structure, the literary equivalent of very short stories. As short stories, picture books generally have at least one character, a setting (place and time), a point of view (angle from which the story is told), a central conflict or story problem (physical, emotional, or both) that drives the plot (sequence of logically connected events), and a variety of themes (controlling ideas or central insights).

Perhaps the most common story pattern, rooted in myth and folklore, is: a character wants something, sets out to get it, encounters an obstacle or series of increasingly difficult obstacles (some sort of rising conflict), finds a way through the obstacle course, and achieves (or fails to achieve) his or her goal. Most

importantly of all, the central character must change in some definite way as a result of the events of the story, preferably just before the ending, at the climax or highest turning point. Writers and artists have spun countless variations on this fundamental pattern throughout history.

The meaning or resonance of a picture-book story is impossible to quantify, but nearly all of the picture-book creators we interviewed for this book have expressed that they seek, in one way or another, an intense emotional connection with their young readers. A good story, like a fine piece of music, catches and keeps a child's attention, engaging both intellect and imagination while expanding the child's sense of self and compassion for others.

1. John Lechner sets up a sense of mystery in this *Sticky Burr* comic strip, © 2009 by John Lechner.

2–3. A fight with a dragon is the conflict in this well-paced sequence and eye-level shot from Scott

Christian Sava's *The Dreamland Chronicles.* © 2009 by Scott Christian Sava.

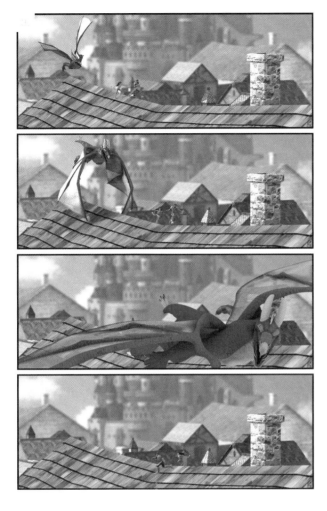

Brian Floca on pacing a story

Working with the page turn is one of my favorite parts of making a picture book. The page turn is a pause physically built into the story you're telling; the act of pulling back a page imposes a pulse on the book. And pages, like doors and curtains, are good for both hiding and revealing. That beat in the rhythm of the reading, coupled with that moment of uncovering, creates suspense: will the rocket lift off successfully? What does the astronaut notice? Turn the page to see. Because this is a picture book, we do see, and will hopefully be intrigued, surprised, or satisfied by what is presented. Even when the moment is less overtly dramatic than a rocket launch (and it usually is), a good page turn reveals new information in a way that creates an interesting relationship between the image just seen and the image being introduced. A page turn like this connects and strengthens both images, and adds meaning to the book as a whole. (See pages 100–103 for more from Floca.)

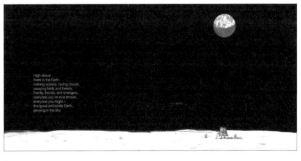

4–5. From *Moonshot: The Flight of Apollo 11* by Brian Floca. The steady pace is suspended for a moment as the implied question of the first spread—what does the astronaut see?—is answered by the second.

Character design and emotion

An illustrator's characters are actors, and they must physically embody the motions and emotions needed to tell the story. Rather than rely on the words to state, "Character A ran happily down the road," for instance, a picture-book artist uses shape (a character's outline or silhouette), color, gesture, posture, facial expression, costume, props—and also composition and lighting—to communicate the same idea to the reader.

Characters are rarely isolated from their settings or other characters, and the ways they interact can be as expressive as how they appear on their own (similarity and contrast between characters are explored on pages 44–45). Capturing a character's essence is one of the illustrator's toughest challenges. Most art teachers recommend drawing character studies based on live models or photographs of actual children, adults, and animals. Posable dummies and self-portraits using a mirror are also helpful. A series of studies might focus on elements of anatomy, movement, expression, color, and more. Some illustrators go so far as to create "model sheets" and "turnarounds" to show characters from different angles to try to keep details consistent. To help craft a distinctive and memorable character, artists often give characters signature visual features (sometimes called "tags") that are immediately legible and help draw the reader's eye to the character. In *Where the Wild Things Are*, for example, Maurice Sendak dresses Max in a wolf suit, which not only tells us much about his personality, but also links him to, and makes him stand out from, the Wild Things.

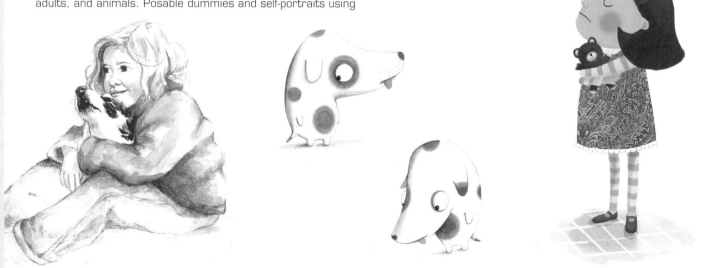

1. Drawing by Lesley Breen Withrow of live models showing close character interaction.

2. Dog characters, © by Sophie Blackall. The multiple poses on a single page serve as a simple model sheet, not unlike those animators use for consistency.

3. Pouting girl by Lesley Breen Withrow. The simplified shapes that make up this character allow her

Anne Sibley O'Brien on showing emotion through gesture and expression

I've been tuned into people's feelings since I was a child, so observing the expression of emotion comes very naturally to me. I've also had extensive training in acting, as a college theater minor and through years of community and professional theater, acting classes, and workshops, so I am used to thinking about what emotions look like. Sometimes I use myself as a laboratory, feeling how the emotion would affect my body, then looking at the pose in the mirror. One of the best sources for ideas are models. I describe the scene to my child models and ask them how they would feel and what they would do if that happened to them. They often respond with wonderfully natural and original gestures and expressions. (See pages 54–55 for more from Anne Sibley O'Brien.)

Characters are the story's actors...

"I almost made it," Jamaica shouted. "Can I be on your team, C
"No, N-O, Jamaica. I told you not to tag along."
"It's not fair. You let Maurice play."
"We need two on a team. Why don't you go play on the swings and stay out of the way?"

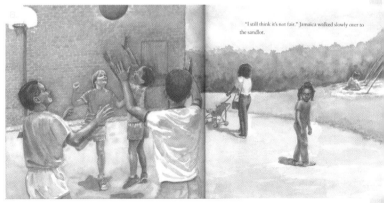

"I still think it's not fair." Jamaica walked slowly over to the sandlot.

emotions to be readable through posture; her expression amplifies her moodiness.

5–6. Spreads from *Jamaica Tag-Along*, written by Juanita Havill and illustrated by Anne Sibley O'Brien.

Character roles

The central or main character, also called the protagonist or hero, is the individual—not always a human being—whose actions the reader follows most closely from first page to last. Each is the one character the reader is meant to care about the most, and is often the one who changes the most from beginning to end. The main character is generally active, meaning that his or her actions and decisions are essential to the course the story takes. This character is often, though not always, the "point of view" character as well; his or her perceptions and attitudes inform the words and pictures. Some picture books have dual main characters (e.g., Arnold Lobel's *Frog and Toad* or James Marshall's *George and Martha*) or multiple or group main characters (e.g., in David Macaulay's *Black and White* or David Wiesner's *The Three Pigs*), whose stories can be shared, parallel, diverging, or intersecting. In some stories, the point of view shifts from one character to another.

1. Dual main characters from an illustration by Lesley Breen Withrow.

2–3. Central character from an in-progress picture-book biography

about the dancer Isadora Duncan by Lesley Breen Withrow.

The New Gladiators

The New Gladiators

When the tree stopped spinning,
Georgia and Charlie steped out.

They found themselves in a crowd of people,
who were wearing clothes
that looked like sheets.

The people were all heading towards
a large old building in the distance.

Georgia and Charlie were in
ancient Rome!
They followed the crowd of people.

11

Russell Tate on building a large cast of background characters

The central spread of *Time Travel: When in Rome* has two modern-day children surrounded by ancient Romans in a street scene. I knew there were two panels of text to go at the top of both pages, so I only had the bottom half to create a crowd. In my initial sketch I tried to work out some main crowd characters first and then fill in some bit players in the gaps and holes around them. As it was a busy street, I thought I would try and get a cross section of people rather than just 200 centurions marching by. The main characters I chose were a boy, a trader, a woman with a water jug, a local busybody, and a Roman official.

As the street seemed to have so many odd people and things going on, I made the expressions of the locals into something more akin to mild amusement as opposed to outright shock. Once I had placed them, I filled in the surrounding space with a few more characters who were also staring at the newcomers. Behind them I included some other, smaller characters including soldiers walking past who were probably oblivious to the visitors.

I tried to make the panels for the text fit into the wall of a building and added more characters inside the building. To make them look different, I turned them into brown silhouettes. This also helped to minimize the visual overload for the reader. With so many faces and expressions, I really wanted the attention to be with the foreground characters.

4. Group of characters from *Time Travel: When in Rome*. Illustration © 2009 by Russell Tate.

Setting and research

A story's setting encompasses both time and place. It is the stage on which the characters act and the world in which they interact. In picture books, setting can refer to the hour of the day and its accompanying weather, and the passage of time from page to page.

Some stories give only a vague conception of setting, like when characters seem to exist only as visual ideas on the page. Other stories—whether fiction or nonfiction, realistic or fantastic—provide more complex and specific elements of geography, history, culture, and society; they might even require maps or timelines to help navigate their limits.

Beyond simply depicting a backdrop for the action, illustrators use setting to express mood, atmosphere, conflict, and factual or emotional information about the cast. Character and setting have a reciprocal relationship; one feeds into the other. Every aspect of a character's surroundings, and the objects or props within it, gives us context about the story that affects how we view the characters, their circumstances, and the physical and societal "rules" operating in their world, which should remain internally consistent throughout the story.

In the highly compressed form of the picture book, much of a story's setting is implied by or to be inferred from the pictures and text. What the reader does not see is often as important as what is explicitly shown. Picture-book illustration is truly an art of suggestion, and master illustrators can build entire worlds through the accumulation of small details and through selective use of cropping and negative space.

1–2. A contemporary and historical exterior setting by Lesley Breen Withrow.

Research and reference

Two of the most valuable tools an illustrator can possess are a sketchbook and a digital camera. Many artists keep elaborate travel journals and visual reference files with titles such as buildings, furnishings, vehicles, animals, and foliage. Others use blogs, photo archiving, and search sites such as Flickr and Google Images to find, store, and share research and inspirational materials. Neither method is superior, and a combination of the two can yield great results, enhancing memory and imagination.

3. Colorful, richly detailed setting that suggests the warmth, closeness, and casual chaos of a young family at home, © 2009 by Elizabeth Matthews.

4. An interior kitchen setting, which provides a background for the action happening at the table. By Lesley Breen Withrow.

Case study:
"Cat's Twelve Tails," part 1

The manuscript

In the picture-book field, as Jack Gantos points out on page 58, "You find every possible relationship between artist and writer— and artists that write, and writers that illustrate." The creative process sometimes begins with sketches and images, and some books have very few or no words at all. However, for text-based books, nearly all publishers require a typed manuscript for initial consideration and editing.

Writer-artists often produce a manuscript in conjunction with a storyboard, or to show the placement of text in the dummy book (more about this in the following pages). Manuscript formats vary by project and by publisher. Specific submission guidelines can usually be found on a publisher's website.

Throughout this section, we present the major steps in creating an in-progress picture book of our own, from completed manuscript through to samples of final art.

"Cat's Twelve Tails" by Steven Withrow

One she wore on Sunday mornings strolling with a friend.
Two she took on pleasant outings by the river bend.
Three she kept for secret errands prowling in the dark.
Four she hid beneath a bush beside the city park.
Five she dressed in scarlet ribbons meant to catch
 the eye.
Of chickadee or meadow mouse or bashful butterfly.
Six she bought on market day and paid a level price.
Seven tagged along behind against her own advice.
Eight she gambled and she lost in midnight games
 of chance.
Nine she broke while practicing a whirling-dervish dance.
Ten she groomed to gleaming black until her tongue
 turned red.
Eleven she abandoned for a buttered crust of bread.
Twelve she had inherited at birth with regal pride.
She curled it close upon her breast and wore it when
 she died.

Steven Withrow on his sample manuscript

"Cat's Twelve Tales" is a poem inspired by my love of Mother Goose nursery rhymes and my fascination with British and American children's verse from the nineteenth and early twentieth centuries (Edward Lear, Lewis Carroll, Christina Rossetti, Eugene Field, Robert Louis Stevenson, A.A. Milne, and T.S. Eliot, among others), as well as the historic tradition of poems about cats.

After I finished revising the poem, I shared it with my wife and coauthor, Lesley Breen Withrow, who immediately saw its visual storytelling possibilities and suggested she try her hand at illustrating it as a 32-page picture book.

She started sketching, and her illustrator's mind soon created a compelling pictorial sequence for the words, adding visual details and making narrative choices I had not anticipated. Within a few weeks, she had constructed a cohesive narrative in pictures, based on the images the lines in the poem suggested to her: the entire life of the central character, in fact.

Seeing the poem anew as the text for a picture book—and a counting book at that—I realized that I had, inadvertently, broken three "cardinal sins" I'd once heard spoken about by a children's book editor at a conference: "Don't use anthropomorphic animals; don't rhyme; and don't *ever* have the main character die."

I hesitated, thinking, "What if nobody wants to publish this?" But, by then, the simple, lyrical story had acquired a life all its own, and Lesley and I both agreed that we had to give the fledgling book a chance to fly, sins and all.

As the writer-artist Mary Jane Begin once advised me about being a writer, "There's always one key ingredient: courage. Without that, not much happens, and it's just the courage to take that thing out of your head and land it on paper, to think it's worthy. Having the courage to say, 'This is an actual story, this is something real'—that takes a lot of chutzpah."

Case study: "Cat's Twelve Tails," part 2

Lesley Breen Withrow on her storyboard

The visual story of "Cat's Twelve Tails" began in my sketchbook as a collection of doodles and character drawings, which evolved through trial and error and careful selection. I drew from observation, research, memory, and imagination. I had at first considered a long, horizontal, rectangular format, but I ended up choosing a 10 x 10in (25.4 x 25.4cm) square format because I wanted to create a book that a small child could hold easily. Also, the tighter dimensions helped me to compress each scene down to its most essential elements.

Like an animator or film director, I created a series of storyboards that gave me an aerial view of the structure of the whole book blocked out across 32 pages (including endpapers, title, and copyright pages, etc.). These thumbnail sequences—without color, texture, or much detail—were convenient tools for quickly sketching out and experimenting with possible visual ideas, page layouts, and story progressions. With each new storyboard, the composition of each double-page spread became more refined, and I could establish how each scene set up and flowed into the next. It also shows the placement of the text.

After drawing her over and over, I grew quite attached to Cat, a young Siamese who lives in an imaginary city. The "tails" of the title represent not only the numbers 1 to 12 (which make this a simple counting book), but also the different "tales" or stages in Cat's life—making this something a little more complex and metaphorical. Cat's tail is also a visual symbol for the passage of time. Cat is growing older and older with each page turn, from the rush and activity of childhood to the quiet grace of old age. I incorporated this idea directly into the opening and closing sections of the book, with the final tail continuing off the page and going on for eternity.

Our ending is a solemn one, so throughout the book I added bits of humor and surprise—the mice, for example, who playfully echo the number on each spread and become thematic companions commenting subtly on the main action. When Steven and I had a picture sequence we were both happy with, we were ready to move on to making the dummy.

1. A page from Lesley's sketchbook.　　**2.** The finished storyboard for "Cat's Twelve Tails."

Each new storyboard
helps refine
the composition.

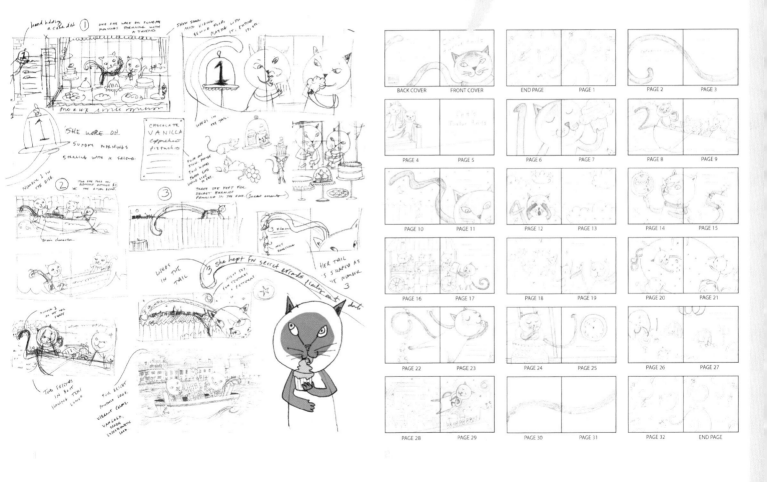

BACK COVER | FRONT COVER END PAGE | PAGE 1 PAGE 2 | PAGE 3

PAGE 4 | PAGE 5 PAGE 6 | PAGE 7 PAGE 8 | PAGE 9

PAGE 10 | PAGE 11 PAGE 12 | PAGE 13 PAGE 14 | PAGE 15

PAGE 16 | PAGE 17 PAGE 18 | PAGE 19 PAGE 20 | PAGE 21

PAGE 22 | PAGE 23 PAGE 24 | PAGE 25 PAGE 26 | PAGE 27

PAGE 28 | PAGE 29 PAGE 30 | PAGE 31 PAGE 32 | END PAGE

Case study: "Cat's Twelve Tails," part 3

The dummy

After finishing the storyboard, Lesley created a simple "working" dummy—a 3-D model of the picture book with the exact trim size (outer dimensions) and number of pages. A dummy allows the illustrator to experience the story progression from cover to cover and the word–picture balance from page to page just as the reader would.

When presenting a picture book to a publisher, author-illustrators often construct more elaborate dummies with color covers and stapled or sewn bindings. However, the majority of editors and art directors we talked with suggested that it was a good idea to start with a simpler dummy with refined black-and-white art, the text placed in a computer font, and with just two spreads taken to the color stage, which gives them enough detail to make an initial decision.

"If you take the entire book to color, you may come across as a bit rigid and too tied to your idea," says Lesley. "At this point you want to get your idea or story across in a clear way and also show that you're flexible enough to work with them. Publishers are going to have ideas based on how they perceive the market.

"You want the art director or editor to see what the book will look like when printed, even though it is in black-and-white. Only artists who have been working in the field for a long time and have a long-standing relationship with the publisher can have super-sketchy art in their dummies. You need the person considering your work to feel comfortable with you as a professional artist and storyteller."

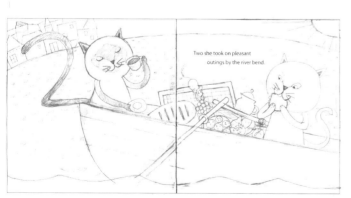

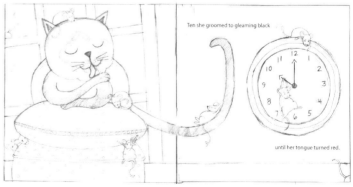

1–2. Two dummy spreads from "Cat's Twelve Tails."

3. One spread taken to its final stage, with colors, patterns, and textures added in Corel Painter and Photoshop.

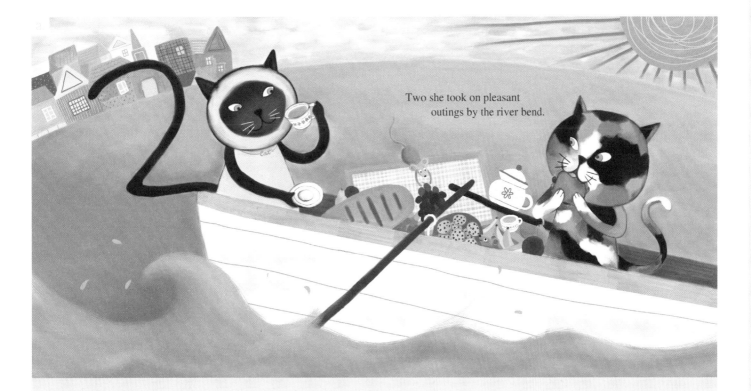

Two she took on pleasant
outings by the river bend.

Close collaboration

As husband and wife, we recognize that our creative partnership is not the normal procedure in children's publishing. As editor and creative consultant Kara LaReau of BlueBird Works LLC says, "Unless the picture-book team has already enjoyed a degree of published success, it's best to let the editor and their design team help in choosing the right illustrator for the text. We have access to a wide range of talent, we have proven experience in matching complementary styles, and we know the market." Nevertheless, we believe our close collaboration was crucial in shaping the visual story that emerged from the poem. We brainstormed ideas separately and together, and Lesley, as the illustrator, was also able to consult the poet (Steven) about some of the nuances in the words. While an editor might disagree, we felt that our picture-book-in-progress was a better blend of our personalities and talents, and the story more fully our own, than would have been possible if we had had no back-and-forth communication. Plus, we also had a lot of fun!

Case study: The Legend of Hong Kil Dong

Anne Sibley O'Brien

Anne Sibley O'Brien has illustrated more than 25 picture books, including *Jamaica's Find* and five other Jamaica books by Juanita Havill, and *Jouanah: A Hmong Cinderella*. She has collaborated with Margy Burns Knight on five books and in 1997 they received the National Education Association Author-Illustrator Human & Civil Rights Award for their body of work.

O'Brien has also illustrated a number of her own books, including two retellings of Korean tales, *The Princess and the Beggar* and *The Legend of Hong Kil Dong: The Robin Hood of Korea*, a picture book in graphic novel form. The latter is a tale set in the fifteenth century about a boy who is denied a place in society because, though his father is a nobleman, his mother is only a servant. Kil Dong learns magic and martial arts and finds his destiny, transforming a group of bandits into an army challenging injustice.

O'Brien's passion for multiracial, multicultural, and global subjects was kindled by her experience of being raised bilingual and bicultural in South Korea as the daughter of medical missionaries. She attended Mount Holyoke College in Massachusetts, where she majored in studio art, and spent her junior year at Ewha Womans University in Seoul, South Korea. She lives with her husband on an island in Maine, and is the mother of two grown children.

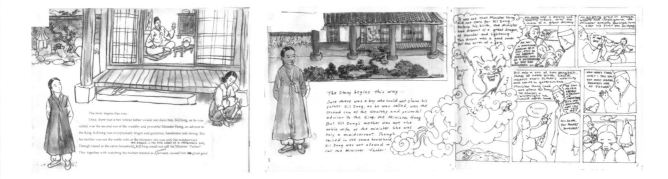

1. Dummy sketch of the first spread as a traditional picture book.

2. Dummy sketch of first spread as a comic book.

3. The final printed spread. All images © 2009 by Anne Sibley

O'Brien, from *The Legend of Hong Kil Dong: The Robin Hood of Korea.*

O'Brien on adapting to the comics form

When I first showed a rough dummy of a picture-book retelling of the story of the Korean hero Hong Kil Dong to my editor, Judy O'Malley at Charlesbridge, she was hesitant about the book's potential given that folktale material is sometimes seen as somewhat dull. I responded that I wasn't satisfied with the book's form yet, that the story was full of action, adventure, and magic, and I wanted it to explode off the page. Judy said, "You mean like a 'ninja graphic novel?'" A lightbulb went off in my head. I thought this was the perfect form in which to tell this story!

The problem was, I had absolutely no idea how to create a graphic novel. I didn't read, collect, or draw comics. The next year and a half were a time of wonderful discovery as I explored a whole new set of tools: the use of panels to organize images, and the division of text into narrative blocks and speech and thought balloons. When making comics, we use the frame to guide the reader's eye to see what you want them to see. I think of the frame as a movie camera viewfinder that can shift angle, perspective, and focus. I am able to develop characters, settings, or plots by moving the frame or zooming in on a character's face to show expression. Before I studied comics, many of my picture-book images were similarly framed, as if I were watching the story I was illustrating unfold on stage. All of the pictures had the same basic frame. Comics released me from the limitations of the theater and put me on a movie set.

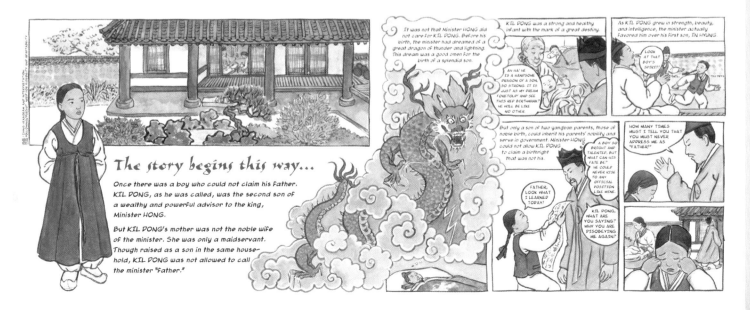

Artist profile:

Steve Adams

Country of origin: Canada
Primary formats: Picture books, editorial illustration
Primary technique: Acrylics

Steve Adams is an award-winning illustrator based in Montreal, Canada. After finishing his graphic design studies in 1994, Adams traveled to Europe to undertake an advanced training course in design. Upon his return, he began collaborating with various publications such as *The Wall Street Journal*, *The Washington Post*, *Chicago Tribune*, *The Globe and Mail*, *La Presse*, and *Harvard Business Review*. Since 1999, he has shared his passion for illustration and graphic design by teaching at a Montreal college and, most recently, at the Université du Québec à Montréal. He has published four books with Canadian publisher Dominique et Compagnie, including an adaptation of Oscar Wilde's *The Happy Prince*, and *Lost Boy* with Dutton Books.

Written by Jen Wojtowicz and illustrated by Adams, *The Boy Who Grew Flowers* was a *ForeWord Magazine* Book of the Year Awards finalist in 2005, and has since been adapted into a play and published in French, Catalan, Spanish, Portuguese, Greek, and Korean. Barefoot Books explains the story: "Rink's grandmother was raised by wolves, his Uncle Dud tames rattlesnakes, and Rink grows beautiful flowers all over his body

When Rink reached his home high on Lonesome Mountain, he went straight to his Uncle Dud's room. He rummaged under the bed until he came up with several feet of Fat Lucy's shucked-off skin.

Next, he dug through his mama's bowling bag until he found a needle and spool of silk thread. Then, in the tumbledown shed off the kitchen, he turned up an old leather mule saddle.

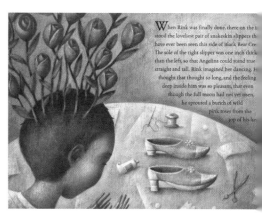

When Rink was finally done, there on the t stood the loveliest pair of snakeskin slippers th have ever been seen this side of Black Bear Cre The sole of the right slipper was one inch thick than the left, so that Angelina could stand true straight and tall. Rink imagined her dancing. I thought that thought so long, and the feeling deep inside him was so pleasant, that even though the full moon had not yet risen, he sprouted a bunch of wild pink roses from the top of his he

when the moon is full. Townspeople just don't understand the Bowagons. But one day a new girl named Angelina arrives at Rink's school, and he soon discovers she has some unique qualities too."

After more than four years of searching for the right artist, Tessa Strickland, publisher of Barefoot Books (see pages 178–179), chose Adams to illustrate *The Boy Who Grew Flowers*. "As soon as I read the text I saw images coming to my mind, and I fell in love with the characters and the story," says Adams.

Adams read the text seven or eight times before sketching the images directly on the manuscript pages. Once he had revised the different sketches generated through discussion with the publisher, he began to produce the artwork in acrylics on cardboard. "I wanted to give an impression of an old painting on wood. Each illustration took 10 to 15 hours to do. I scanned the illustrations myself, and provided them to the publisher as digital illustrations. I always prefer to control this part of my work. At the beginning, Barefoot wanted to take charge of the scanning process, but it was one of my conditions when accepting this project to do it myself, to which they agreed."

Of his primary audience and how they might approach such an unconventional book, Adams says, "Children understand a lot more than we expect. Illustrations talk to them on a different level than words do. Sometimes they understand more with a spot of color or a close-up image than with a sentence. Illustration is their language, and I'm on their territory. When I make an illustration for adults, it's generally one strong idea, one shot, one image—it doesn't live long in the reader's mind. In children's books, it's a series of illustrations telling a story, with a long development and the same characters page after page. A book lasts longer, and sometimes as long as childhood itself, or a whole lifetime!"

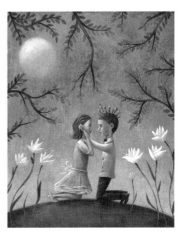

After the dance, Rink walked Angelina home. They stopped on the way and sat under an old buttonball tree. Angelina told Rink about her family, and he told her about his.

Then, with a pounding heart, he revealed to her the fact that he sprouted flowers all over himself during the full moon. Angelina smiled with delight. Then she bent down and showed Rink where the flower she wore grew right out from behind her ear!

1–3. Interior spreads from *The Boy Who Grew Flowers*.
© 2005 Jennifer Wojtowicz and Steve Adams.

Reproduced by kind permission of Barefoot Books.

Expert commentary:
Jack Gantos

While in college, writer Jack Gantos and illustrator Nicole Rubel began working on picture books together, with their first book, Rotten Ralph, *published in 1976. Gantos continued to write children's books and began to teach courses in children's book writing and literature. He developed the master's degree program in children's book writing at Emerson College and the Vermont College of Fine Arts MFA program for children's book writers. His many award-winning books for older readers include* Jack on the Tracks: Four Seasons of Fifth Grade, Joey Pigza Swallowed the Key *(which was a National Book Award for Young People's Literature finalist in 1998),* Joey Pigza Loses Control *(Newbery Honor winner in 2001),* Hole in My Life *(Michael L. Printz Honor and Sibert Honor winner in 2002), and* The Love Curse of the Rumbaughs. *Gantos now devotes his time to writing books and educational speaking.*

How do you define a picture book?

On one hand, a novel with spot illustrations is not technically a picture book (e.g., *The Invention of Hugo Cabret* by Brian Selznick or *From the Mixed-Up Files of Mrs. Basil E. Frankweiler* by E.L. Konigsburg). On the other hand, a book that tells a story through pictures with no text at all is a very pure picture book (e.g., *Robot Dreams* by Sara Varon or *The Midnight Circus* by Peter Collington). Between these two extremes there is a lot of room for definition. Most generally, a picture book is a book that is a fairly well balanced combination of text and pictures.

What do you see as the writer's role when creating a picture book? Do you think there should be a lot of communication between writer and artist?

The writer's role is to write the bones of a good story, which can then be robustly expanded upon with generously conceived illustrations. Whatever communication is necessary to achieve the best possible book is the precise balance between the two artists. The marriage between text and art cannot be codified until the final book is realized.

Some critics say that the ideal picture book is written by the artist in direct conjunction with the images, rather than having an illustrator work from a written manuscript. Do you agree with this idea?

No, I don't agree. If you look carefully at the history of the picture book you find every possible relationship between artist and writer—and artists that write, and writers that illustrate.

There is no rule of thumb about who should do what in the creation of the book. It is interesting to have an inside understanding of how an illustrator and writer work together, or how one creator does both, but ultimately it is the finished book that is the most important focus. If it is a great book then it doesn't matter who did what, since the book itself is a pure work of exceptional art that certainly trumps the creator's role.

What are three of your all-time favorite picture books, and three of your favorite more recent picture books?

This is nearly impossible to answer with any critical pride. Three of my all-time favorite books from a list of thousands include *No Kiss for Mother* by Tomi Ungerer, *Chrysanthemum* by Kevin Henkes, and *Willis* by James Marshall. More recent favorites include *Arnie, the Doughnut* by Laurie Keller, *The Wall: Growing Up Behind the Iron Curtain* by Peter Sís, and *The Arrival* by Shaun Tan.

What advice do you have for new and aspiring authors and illustrators?

I think the most important step when creating picture books is to settle down and read as many of the fine picture books that have been published in roughly the last 60 years as you can. All of the odds and ends of advice on how to write and illustrate are clearly revealed through a slow, pleasurable reading of the great books that came before. Then use what you learn—surge forward on the inspiration from reading to fully reveal your own innate creative impulse. Learn from the past to become the future.

How would you describe the landscape of American children's literature today? What changes have you seen over the course of your career?

Year after year, there is a fairly short list of brilliant picture books and novels released (novels that range from upper elementary to young adult). There are also tremendous achievements being made in nonfiction books. Some time ago I was informed that there were approximately 16,000 children's books published each year. Whether or not this is true, the important thing to consider is the number of quality books coming out. I published my first book in 1976. There were fewer books published for children then, but plenty of good ones. It seems to me—and this is entirely a subjective consideration—that it doesn't matter how many children's books are published, there are only so many truly outstanding ones. And by outstanding, I mean there are dozens of books that are well written, finely illustrated, and memorable. The book awards focus on the top two, three, or four, but the awards do not fully reveal the richness of the many books published. Instead, they actually narrow the creative boundary of the field down to a few books each year rather than show off the immense range. I am not against awards, but the true award is in reading a great book; the careful reader has to read hundreds of children's books and make up their own mind as to what is significant, fulfilling, and lasting.

Traditional Tools

Pen and ink

Along with the simple pencil sketch, black ink on a blank page has long been the foundational technique of children's book illustration—who can imagine the art of childhood without also envisioning the unique line work of Beatrix Potter, Ernest Shepard, Garth Williams, Robert McCloskey, or Maurice Sendak, to name a few modern masters? Although printing processes have evolved from the earliest woodblock impressions to today's digital color presses, inking with a pen or brush has remained central to picture-book art.

Drawing in ink

Ink drawings consist of a series of marks—points and lines —that work together to create different tones (shades of gray, darkness, or lightness). Tone defines different shapes and gives dimensionality to otherwise flat images. You can vary tone through the quantity, density, and proximity of your lines. Simply put, each layer of lines gradually darkens the tone, and the closer together you draw your lines, the darker your drawing will appear.

The basic tool of pen and ink drawing is a pen or stylus with a variety of nibs that allow you to create different thicknesses, widths, or weights, and which can alter the expressiveness (precision, action, emotion, or texture) of the line. Many ink artists also work with a range of technical pens (e.g., Rotring Rapidographs) or brushes. You can use anything from black India ink to a variety of colored inks. Also, artists often apply colors over or under their inked lines, and the combination brings about interesting effects.

Hatching

Hatching is drawing in straight parallel lines, or hachures, to create a tone.

Crosshatching

Parallel lines in one direction are crossed by lines or strokes that run in the opposite direction. This technique is used to create deeper tones than hatching.

Pointillism and stippling

Here, dots are applied in specific or random patterns that work together to create a shape.

Altering tone

When the dots and lines are close together, the tone is dark, and when they are farther apart, the tone is light.

Contour lines

These are lines that curve and cross each other in a pattern that creates a rounded look.

Scribbling

This refers to random hatching or marks that have a free, sketchy look.

Patterns

Here are some examples of patterns you can create with pen and ink.

Crosshatching in action

Here is an example of how crosshatching can be used to create tones.

Workthrough: Pen and ink

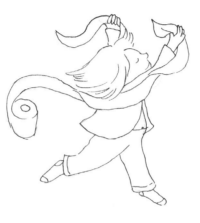

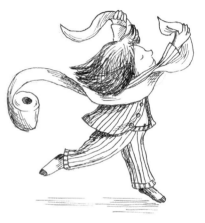

1. Begin with a pencil sketch. Draw the image lightly so that it is easy to erase or is virtually invisible under the final art.

2. Next, draw over the pencil sketch with permanent India ink. (It's important to remember that inking is more than just tracing over pencil lines, and many creative decisions and improvisations are made at this stage.) Erase the pencil sketch that is underneath. Keep your lines steady and brisk for maximum expressiveness.

3. Now we begin to fill in the art with tones using hatching and crosshatching techniques. You can also achieve similar effects by using the stippling or scribbling techniques.

Illustrations by Lesley Breen Withrow.

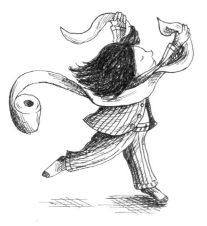

4. Continue to add more hatching and crosshatching so that the shapes of the girl and the streamer become more rounded and defined. The contrast between the solid or "spotted" black of the girl's hair and the solid white of the streamer (as well as the relative lightness of the pajamas) draws the reader's eye and causes the character's figure to "pop" forward.

5. Add the ground using a repeated line that creates a uniform texture distinct from the tight crosshatch pattern of the wall in the background.

6. You can further "pull" the character and the paper into the foreground by increasing the weight of the outlines. To "push" the wall and the floor into the background you can add more depth and shadow using additional horizontal crosshatching. The goal is to achieve a balance of tones that serves the composition of the image and the story you are telling.

Workthrough: Watercolor painting

Tutor: Cheryl Kirk Noll

Cheryl Kirk Noll is a Rhode Island-based illustrator specializing in multicultural and historic illustration for children. Her published work includes children's picture books, textbooks, posters, greeting cards, teacher and parent resource books, and children's magazines. She teaches in the children's book illustration continuing education certificate program at Rhode Island School of Design. Here she shares a tutorial on creating a night scene using watercolor washes and resist for *The Black Regiment of the American Revolution*, written by Linda Crotta Brennan.

Transfer sketch

I transfer my initial sketch onto 140lb Arches cold press watercolor paper using a light table and a #2 (HB) pencil, which can be erased easily.

The watercolor medium

Watercolor is a painting method and one of the most popular techniques used in picture-book art around the world. Watercolor paints are made of pigments suspended in a water-soluble vehicle. The most common support for watercolor paintings is paper, but artists have also used papyrus, bark papers, plastics, vellum, leather, fabric, wood, and canvas. Watercolor painting with ink, common in East Asia, is referred to as brush painting or scroll painting.

> *Watercolor is one of the most popular painting techniques.*

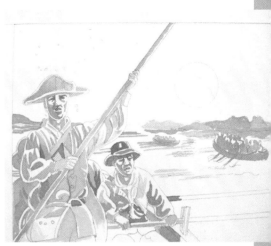

Underpaint

I create form by painting shadow areas. A variety of colors work for this step, but my favorite is Winsor Violet from Winsor & Newton, a staining color that stays put when overpainted.

Stretch the paper

This can be done in a variety of ways. My method is to soak the paper (pencil sketch already transferred) in a well-cleaned sink, blot it with a towel, and staple the damp paper to sturdy, triple-corrugated board. Laying the board flat, I let the paper dry completely. When dry, I tape the borders with artist's tape.

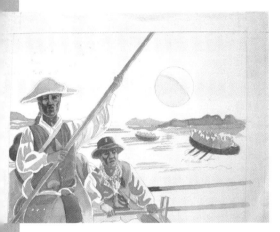

Glaze

I glaze layers of color over the underpainting to create form. At this stage I don't paint with colors that will lift or run when overpainted, such as Cadmium Red. The glazes are transparent, allowing the underpainting to show through.

Apply the resist

I plan to glaze layers of a blue wash over the entire piece to create a night scene, but I want the moon and stars, as well as the areas where moonlight is hitting the men, boats, and water, to remain paper white, or the color I have already applied. To do this, I apply Winsor & Newton masking fluid, also known as liquid frisket or resist. Resist is tricky to work with because it is globby, almost like rubber cement, so I use an inexpensive synthetic brush and brush it on a bar of soap, which makes the brush easier to clean afterwards. I paint the resist on all areas that I don't want the blue wash to touch. This is often a tricky stage, and I frequently clean and resoap the brush. When I've finished painting with the resist I touch up any pinholes or thin areas where the wash might seep through, and let the masking fluid dry thoroughly.

Lay a wash

To create a flat, even wash of dark blue over the entire piece, I mix a generous well of color using a mix of French ultramarine with a touch of burnt sienna, and keep it well stirred so that the pigment is evenly suspended. Tilting the board, I load a good-quality, one-inch sable brush with paint and drag it across the top of the art, overlapping onto the tape. A small lip of liquid should form along the bottom of the stroke, and I again begin on the left, dragging the brush all the way across and "catching the drip." I reload my brush as needed. The quality of the brush determines the amount of liquid that it will hold (a better quality brush equals more holding power).

When the entire page is covered, I soak up the excess liquid from the bottom, or it will spread back up into my art. This can create beautiful effects, but it's not what I'm looking for here. Depending on the piece, I may layer one wash or many, generally allowing one wash to dry before applying a second. Washes appear lighter as they dry, so wait until the watercolor has completely dried. The watercolor often beads up on top of the areas covered with resist, so I double-check to make sure those areas are dry, too. I lift the mask by rubbing it with my fingers, a rubber cement remover, or an eraser. The resist will often lift pencil lines and a touch of color, so keep this in mind.

Finish

I then paint my darks and any colors I couldn't lay a wash over. The light areas will often appear too harsh, so I work back into the painting to soften areas and add detail.

Case study: Gouache

Nancy Cote on painting in gouache

Based in Somerset, Massachusetts, Nancy Cote has illustrated 28 picture books for young readers. She has written and illustrated Jackson's Blanket, It's All About Me!, It Feels Like Snow!, Flip-Flops, *and* Palm Trees. *Several of her books have earned national awards, including the Oppenheim Toy Portfolio Gold Seal Award, the American Booksellers Association "Pick of the Lists," the Society of School Librarians International Honor Book, the Smithsonian Notable Book for Children, the Sydney Taylor Notable Children's Trade Book, and the IRA-CBC Notable Children's Trade Book. Her work has been featured in the "Original Art" Exhibit at the Society of Illustrators in New York City. Along with writing and illustrating children's books full time, Cote also teaches children's book illustration in the continuing education certificate program at Rhode Island School of Design. Here she shares her thoughts on painting in the medium of gouache.*

The medium that I use most often when illustrating is gouache, an opaque, water-based paint. I have used gouache in several different ways over the years. At first I used it sparingly and applied it like watercolor, which is somewhat contrary to its nature. Although it is flexible enough to work transparently, I have found that gouache is best applied with a thicker consistency as an opaque medium.

Whereas watercolor relies on the whiteness of the paper to create light from within, gouache remains on the surface of the paper, creating light from the brilliance of the pigment. With gouache, you can achieve flat areas of rich matte color that can be layered, much like oil painting. The major difference is that it dries immediately, and because of its matte finish, colored pencil and other mediums are more easily applied. With gouache, colors generally dry to a different value, making color matching difficult. For example, light tones might dry darker, and dark tones tend to dry to a lighter shade, leading one to mix larger amounts of paint for color consistency. This challenge in controlling the medium is one of the many qualities that I enjoy about working with gouache.

Although it is an ongoing struggle, I find the process exhilarating. Many surprises occur and I am reintroduced to a medium that I thought I knew everything about. Utilizing layering techniques, bold colors, textures, lines, and patterns,

1. Illustration from the in-progress book, *Monketty Monk*, by Nancy Cote.

gouache keeps me interested and engaged in a medium of endless possibilities. It also lends itself nicely to the whimsical and folksy style that is characteristic of my work.

I consider what I do as serious play, approaching artwork and almost everything I do with an attitude of chance. I invest myself fully in the unknown each day, hoping to accomplish something worthwhile but not counting on it. Gouache permits me to make mistakes and to recognize elements that keep my work fresh. I am always searching and reaching for something that I cannot even describe, and for me, gouache is the perfect vehicle for attaining this.

Gouache creates light from the pigment's brilliance.

2. Illustration from the in-progress book, *Leonard's Beard*, by Nancy Cote.

3. Untitled illustration, by Nancy Cote.

4. Illustration from the in-progress book, *The Little Red Coat*, by Nancy Cote. All images © 2009 Nancy Cote.

Workthrough: 3-D cut-paper collage

Tutor: Judith Moffatt

Judith Moffatt is an artist from Massachusetts who has illustrated more than 50 books for young children. Her love for paper began at an early age when her father would bring home boxes of paper scraps from the printing presses where he worked. After a brief career in advertising, she decided to follow her lifelong dream of becoming a children's book illustrator. Eventually, having tried other traditional techniques, she evolved her award-winning, three-dimensional, cut-paper style. She counts artists Leo Monahan and Tomie dePaola among her greatest influences. Moffatt says, "I've always had a hard time imagining where my shadows would fall in an illustration. With 3-D cut paper, the layers create their own shadows and this problem is solved. Working in 3-D is more like playing with paper dolls than work for me. Once all of the characters are finished, they hang around my art desk waiting for me to create their new environment." Here she shares her basic process for creating a 3-D cut-paper piece.

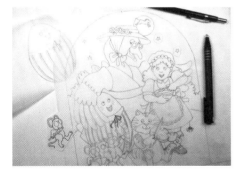

1. First, I make many sketches until I have the design just the way I want it. Then I transfer it carefully onto tracing paper (this will become my pattern).

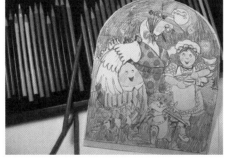

2. I choose my colors by filling in numerous photocopied sketches with colored pencils. When I'm finished, I take my favorite one and match colored papers to the sketch.

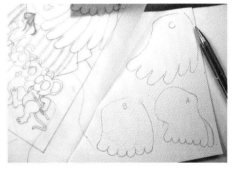

3. Using transfer paper, I trace my shapes onto the chosen colors and letter or number each shape. Here you can see the parts that will make up Mother Goose's wings.

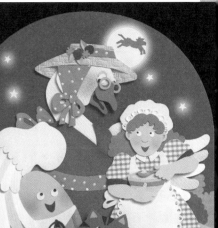

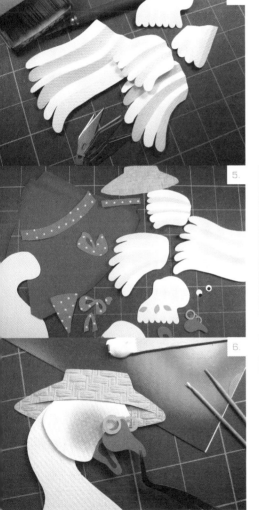

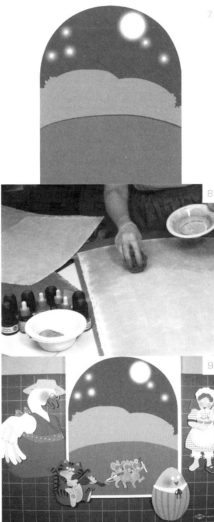

4. I carefully cut and score each piece. I can go through half a box of X-Acto blades when I'm illustrating a 32-page book!

5. Here are all of Mother Goose's parts ready to be assembled.

6. I use acid-free paste, tweezers, and toothpicks to patiently glue my characters together.

7. For special effects, such as a glowing moon and stars, I often create my backgrounds digitally.

8. To add interest, I often sponge papers to give the piece texture. This green will be used as the grass in the finished piece.

9. Here are all my characters waiting to be placed onto their background.

10. The final piece: Mother Goose and Friends.

Other traditional media

Options for traditional artists have never been greater, thanks to the sophistication of today's printers and producers of picture books. In this book we examine a number of common techniques, but there are other media and methods that are equally useful for illustrators. A good place to start is to work from a general-purpose technical reference book for artists (see pages 184–185). Taking an art class taught by an experienced instructor at a local college or university is also an excellent, though more costly, idea. Beginners and veterans alike can benefit greatly from the advice and criticism of a skilled teacher.

Dry media

These include pencil, charcoal, conté crayons, sanguine, soft and hard pastels, and oil pastels (also called wax oil crayons). Colors, thicknesses, and forms vary in each of these media. Drawings can, in some, be easily smudged and blended, while others, especially graphite and pastel pencils, are better for fine detail work. Another drawing medium is scratchboard, which employs a "subtractive" technique in which the artist uses sharp tools to scratch away black ink covering a white surface.

Painters' media

Oil, the medium of choice for the "great masters" of the European painting tradition since the fifteenth century, consists of a pigment (color) bound together with an oil medium, usually linseed oil. Oil is slow to dry and therefore can be reworked by the artist. Acrylic, developed in the late 1940s, is a fast-drying, synthetic paint that combines properties of oil and watercolor. Effects vary from thin washes to thick brushwork. Contemporary artists have discovered innovative ways of manipulating the effects of acrylics. Less common in children's picture books than oil or acrylic, tempera is a paint made from ground pigment bound together with egg-yolk and water. It is generally painted on an absorbent white substance called gesso. Because tempera is very quick to dry, reworking an image in this medium is difficult.

1.

1–2. These two pieces are a combination of acrylic gouache and regular transparent acrylics. The artist donated her owl illustration to the Festival Owl Project for Keene State College Children's Literature Department in 2008. © Barbara Johansen Newman.

2.

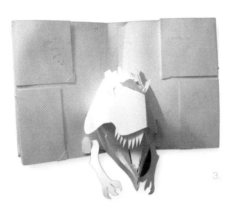

3.

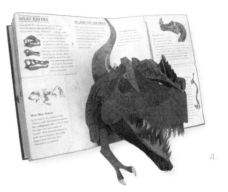

4.

Sculptors' media

These include assemblage (complex compositions of common objects carefully arranged and then photographed to form pictures and scenes), modeling clay, and paper engineering (pop-up books and books with paper-based novelty devices such as pull tabs and flaps). Sculptural illustrators bring actual depth and even movement to their creations. Even in the case of photographed media such as assemblage, where the three-dimensional constructions are flattened, a sense of dimensionality is still present.

Printmakers' media

These often labor-intensive processes include etchings, linoleum cuts (linocuts), monotype prints, and woodcuts. Caldecott medalist Mary Azarian used woodcuts to stunning effect in illustrating *Snowflake Bentley*, written by Jacqueline Briggs Martin.

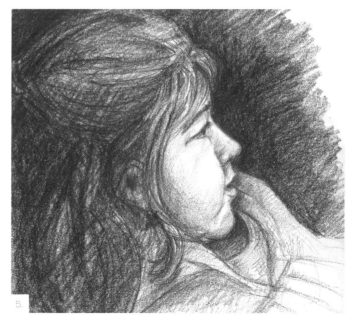

5.

3–4. Early and final stages of a pop-up illustration from *ENCYCLOPEDIA PREHISTORICA:* *DINOSAURS.* © 2005 by Robert Sabuda and Matthew Reinhart. Reproduced by kind permission of the publisher, Candlewick Press, Somerville, MA.

5. Child's portrait created using conté crayon, by Lesley Breen Withrow.

Case study: Tex & Sugar

Barbara Johansen Newman

Massachusetts-based author-artist Barbara Johansen Newman has been illustrating for more than 25 years. Before this she was a soft sculpture artist and puppeteer. Here she shares her thoughts on the creation of Tex & Sugar: A Big City Kitty Ditty, *her first book as both author and illustrator.*

Immersing myself in the theme of two cowboy kitties that seek fame and fortune in New York City was pure pleasure. I had enormous fun looking at many books about cowboys, cattle, western clothing, and city streets. I studied the way cattle stand, horses sit, and pigs poke around. This was essential because cattle, horses, and pigs were not really part of my drawing repertoire. I had to acquire those "files" in my head before I could recreate them.

Looking at pictures is something I do before I begin, as I draw only from my imagination. Working in this way gives me confidence that my work will always look like it came authentically from my own hand and will have my own whimsical style.

Rather than creating thumbnails for a book dummy, I began to sketch in pencil on watercolor paper. Using big sheets of very good paper was surprisingly liberating and made me less precious about getting character ideas down. Once I crossed that threshold, I was off and running and the book took form.

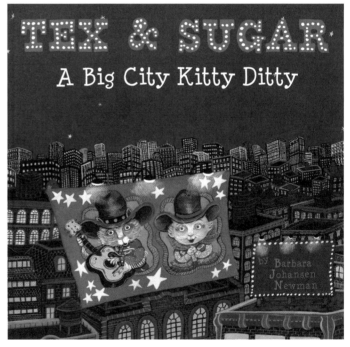

1.

1. Cover of *Tex & Sugar: A Big City Kitty Ditty.* © by Barbara Johansen Newman. Used with permission from Sterling Publishing Co., Inc.

2.

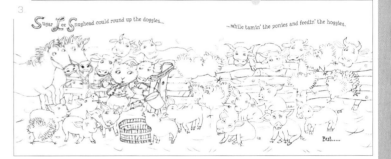

> *"Tex & Sugar"*
> *began in pencil on*
> *watercolor paper*

3.

4.

With each sketch, I first drew all of the scene's components. While I drew I listened to audio books and a lot of country music. I then scanned my sketches and, using Adobe Photoshop and a graphics tablet, cleaned up the sketches and combined different parts to create compositions. It was easy to lasso parts of the roughs, move them around, change the size, or even reverse them. I made additional drawings in Corel Painter using the Soft Vine Charcoal tool.

To start painting, I changed the line art for each piece to sepia tone using Photoshop and printed the art onto hot press watercolor paper at 180 percent larger than the size the printed art would be. I then coated the printed line art with matte medium infused with some burnt sienna to cover the paper with an overall tone, and also to seal it. I painted the pictures using acrylic gouache and transparent acrylics, which I mixed with matte medium. Ultimately, almost every single line I had originally drawn was covered with paint.

Overall, *Tex & Sugar* took 10 months of 12-hour days, 7 days a week. It had a cast of thousands, and it was truly a labor of love.

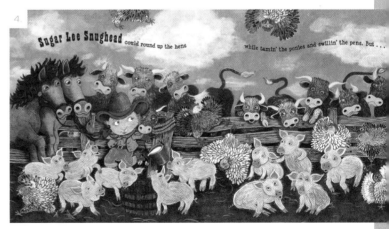

2. Composite sketch for a double-page spread.

3. Line art with text added.

4. Final art.

Artist profile:

Sophie Blackall

Country of origin: Australia (now living in USA)
Primary formats: Picture books, chapter books, commercial illustration
Primary techniques: Ink, watercolors

Sophie Blackall is originally from Sydney, but now lives and works in New York City. Her sophisticated and engaging illustrations are sought after by art directors around the world. She lists Japanese woodblocks, jellyfish, *Moby Dick*, iridescent feathers, firecrackers, foxes, and pieces of string among her influences.

In Australia, Blackall says she had to be a "jack of all trades" to get enough work to survive. "I had a gouache style, a collage style, a pen-and-ink style, and worked consistently in all of them for anyone who would employ me. Coming to New York forced me to sharpen my wit, hone my style, and concentrate fiercely, which isn't always easy with a baby and toddler in a one-bedroom apartment."

For her illustrations, Blackall primarily uses Chinese ink and Schmincke watercolors. As for her creative process, she first reads the manuscript to herself, then to her two children, and decides on the book's trim size. The most important step for Blackall is deciding what the characters will look like: human or animal, contemporary or period. Once the characters have been developed, she draws the whole dummy. When she gets the go-ahead from the publisher she begins painting, which is her favorite part.

"I think new illustrators have to think very creatively about what they can do that is fresh, inventive, and distinctive," she says.

1. Blackall's workspace.

2. Puffin illustration for a personal project.

3. "S," an alphabet letter for a charity project.

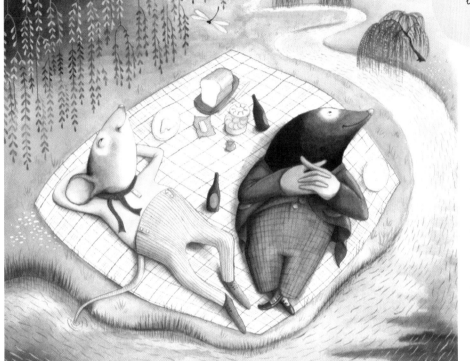

4.

"Going to book fairs, as exhausting and expensive as this can be, is a fantastic opportunity to see what's going on in the world, what stands out in the crowd, and how people respond to it. Failing this, poring over books in an independent bookstore or library is always a good thing to do too."

Some of Blackall's books

Ruby's Wish, written by Shirin Yim Bridges (Ezra Jack Keats Award for Best New Illustrator, 2003)
Meet Wild Boars, written by Meg Rosoff (Society of Illustrators Founders' Award, 2005)
Ivy and Bean series, written by Annie Barrows (ALA Notable Children's Books, 2007)
Red Butterfly: How a Princess Smuggled the Secret of Silk Out of China, written by Deborah Noyes
Jumpy Jack & Googily, written by Meg Rosoff
Wild Boars Cook, written by Meg Rosoff

4. An unpublished book cover for Kenneth Grahame's *The Wind in the Willows*.

All images © Sophie Blackall.

Artist profile:

Lisa Jahn-Clough

Country of origin: USA
Primary formats: Picture books, young adult novels
Primary technique: Gouache

Lisa Jahn-Clough lived on a farm in New England during much of her childhood, and remembers those early years as idyllic. While living in Maine, before she had even learned to write, she decided she wanted to make books. At first she would dictate stories to her father, who wrote them down in a blank book she had tied together with string. She would then draw pictures to go with the story. Jahn-Clough also greatly enjoyed reading, mostly books about young girls such as the Eloise series (by Kay Thompson and Hilary Knight), *Ramona Quimby*, *Harriet the Spy*, *The Secret Garden*, and *Little Women*, as well as biographies.

Her love of visual art developed naturally through the influence of her mother, a painter. "She handed my brother and me paper and paint practically at birth and let us go to it. I have always been intrigued with making cards, books, decorations, paper cut-outs, collage, potato prints, and wood carvings."

When in college in 1990, Jahn-Clough wrote and illustrated a small book (3 × 4in/7.6 × 10.16cm, with black-and-white drawings and handwritten text, tied with ribbon) called *Alicia and Her Happy Way of Life*, which led her to self-publish four other books about Alicia under the publishing name Arm-In-Arm Press. Later, Houghton Mifflin published *Alicia Has a Bad Day* and *My Happy Birthday Book* in different forms. Several other picture books have followed from the same publisher, including *My Friend and I*, *Missing Molly*, and *On the Hill*.

1–2. Storyboard art and text for
Little Dog, by Lisa Jahn-Clough.

Jahn-Clough started
her career by self-
publishing books.

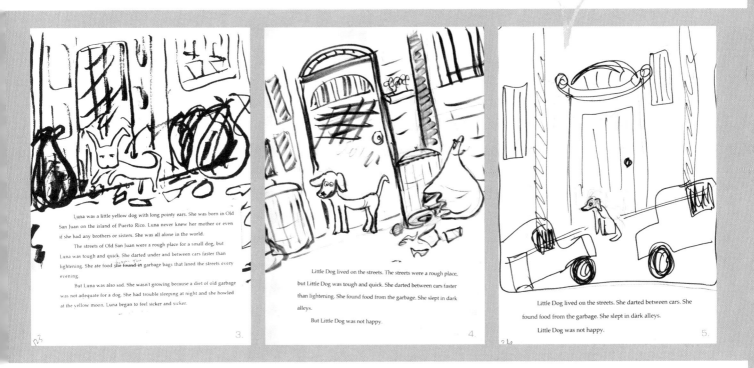

Luna was a little yellow dog with long pointy ears. She was born in Old
San Juan on the island of Puerto Rico. Luna never knew her mother or even
if she had any brothers or sisters. She was all alone in the world.

The streets of Old San Juan were a rough place for a small dog, but
Luna was tough and quick. She darted under and between cars faster than
lightening. She ate food she found in garbage bags that lined the streets every
evening.

But Luna was also sad. She wasn't growing because a diet of old garbage
was not adequate for a dog. She had trouble sleeping at night and she howled
at the yellow moon. Luna began to feel sicker and sicker.

3.

Little Dog lived on the streets. The streets were a rough place,
but Little Dog was tough and quick. She darted between cars faster
than lightening. She found food from the garbage. She slept in dark
alleys.

But Little Dog was not happy.

4.

Little Dog lived on the streets. She darted between cars. She
found food from the garbage. She slept in dark alleys.

Little Dog was not happy.

5.

3–5. Progression of a single page, from initial sketch and text through to revisions from the dummy of *Little Dog*.

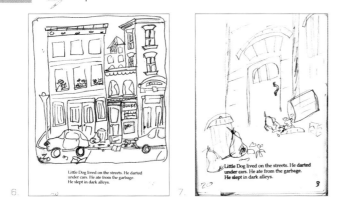

After teaching writing for children for several years at Emerson College in Boston, where she had received her MFA, Jahn-Clough was the interim chair of the Illustration Department at Maine College of Art from 2005 to 2008. She currently teaches at Hamline University in the low-residency MFA writing for children program. Houghton Mifflin recently published her two young adult novels, *Country Girl, City Girl* and *Me, Penelope*, and she is now working on a sequel to the latter.

Little Dog lived on the streets. He darted under cars. He ate food from the garbage. He slept in dark alleys.

Bringing life to *Little Dog*

Jahn-Clough's most recent picture book, *Little Dog*, is loosely based on her dog, Happy, who is a rescue dog from the streets of Puerto Rico.

"The first draft of *Little Dog* was much more realistic and true to my own complicated life, until I fictionalized and simplified it to make the story work better," says Jahn-Clough. "That draft was an insane 2,000-plus words, and was very complicated, with subplots and unnecessary storylines. As with all my picture books, I have to whittle away the text to get to the heart, which generally starts with the main character's desire—what they want more than anything else in the world. In the case of Little Dog, he wants to love and be loved. To get it, he happens to find someone else who has a similar need, and they come together and help each other."

Jahn-Clough started by writing a draft of the text and then put it into a dummy book with sketches on each page. After mapping out the words in a 16-page grid, with a peaking point around page 12, she made a thumbnail storyboard of the art. She then worked out a series of revised 32-page dummies. "The most fun is putting the dummy together, especially the first one," she says. "Getting the plot right is always the hardest. Figuring out what the story is really about takes numerous attempts, and it often gets maddeningly worse before it gets better."

6–8. Progression of a single page, from initial sketch and text through to revisions and a finished color page, from the dummy of *Little Dog*.

9. 10.

This preparatory work is essential to Jahn-Clough's creative process. She notes, "I make many, many dummies, since I really need to see it as a book to make sure it flows, page by page. The main thing is getting the character down on the very first page. The first page of *Little Dog* originally had 129 words, which was way too many. When I did the art, I realized I could cut at least half those words. For example, why say there is garbage all over the street when you can show it in the art, and who cares if Little Dog had brothers and sisters—that's not what the story is about. All I need to establish is a character and a mood.

"In the end, I whittled those 129 words down to 'Little Dog lived on the streets.' These six words combined with an image of a dark, lonely, empty street with foreboding buildings and a small yellow dog hiding by an overturned garbage can, were enough for me to set the tone."

As a mostly self-taught artist whose editor once suggested she shouldn't take the illustration class she had signed up for, Lisa Jahn-Clough is a little hesitant to give artistic advice. But, in spite of this, she says, "I think it's important to have a confident line, whether that comes from having an artistic family, or studying in art school—it doesn't matter, so long as you draw a lot. I do, however, think it is important to learn about narrative structure and character, which is mainly done through reading, writing, and workshopping."

9–10. Assorted images of various dummies of *Little Dog*.

Images © 2009 Lisa Jahn-Clough.

Mary Jane Begin

Country of origin: USA
Primary formats: Picture books, commercial illustration
Primary techniques: Watercolors, acrylics, pastels

Mary Jane Begin started her career as a student in the illustration department at the Rhode Island School of Design, where she has been teaching since 1991. Her award-winning portfolio includes the children's books *The Porcupine Mouse*, *Little Mouse's Painting*, *Before I Go to Sleep*, *A Mouse Told His Mother*, *Jeremy's First Haircut*, *R Is for Rhode Island Red*, and a retelling of *The Sorcerer's Apprentice*. She has received awards from The Society of Illustrators, and her work has been featured in *Communication Arts* magazine. She was the first living artist shown in a solo exhibition at the National Museum of American Illustration.

In 2002, Begin illustrated a new edition of Kenneth Grahame's *The Wind in the Willows* in anticipation of the book's centennial in 2008. This project sparked the idea for a prequel to Grahame's classic book—a series of three small books collectively titled *Willow Buds*, each telling childhood stories of Toady, Ratty, Badger, and Mole. Little, Brown and Company published the first two in the series, *The Tale of Toad and Badger* and *When Toady Met Ratty*, with a third book, *Mole, Lost and Found*, to follow.

1–3. Final art from the first two Willow Buds books.

The story process

While illustrating *The Wind in the Willows*, Begin read the book more than a dozen times to fully absorb the essence of the tale, settings, and writing style. In doing so, she felt she began to know the characters as though they were members of her own family.

"After publication of the book, I continued to wonder how these characters had originally become friends, and decided that I needed to translate it further still," she says. "Something intrinsic to the Willow Buds stories is that the source of inspiration comes from my own life. The first book in particular is based on my childhood, and I cast my brothers and myself as Grahame's animal characters. Grahame himself based his characters on his own brothers, sisters, and son Alistair... a fitting coincidence I was happy to discover!"

Such intimate knowledge proved to be critical for Begin when creating Willow Buds, which she describes as a "difficult dance." From the outset she wanted the series to feel fresh and contemporary, with a great deal of movement and activity, a vibrant color palette, and a surreal sensibility. At the same time, however, she wanted to be true to the spirit of Grahame's work and to the Victorian era of the characters' youth.

4. Cover art for *The Wind in the Willows*.

For inspiration (see right), Begin gathered historical references and studied the work of other illustrators. "As I worked on the stories, a look and feel began to brew in my head, and I had to gather the source material to be able to translate it," she says. "I started to look for visual references that would fill in the blanks. It's very much like what I do when I'm writing a story. Once I've gathered enough visual information, I can start to sketch."

Begin develops her stories almost completely in her head, usually while driving or before she falls asleep at night. When it feels like she has the whole story arced from beginning to end, and all the necessary components are in place, only then can she start writing on the computer.

Says Begin, "I work out all the permutations and plotlines mentally, and then I go over them and add more and more detail, until the point when I'm itching to write it. When I start the dummy, I begin to pare down the physical amount of text that I've written, which helps me to *show* something rather than *tell* it.

"Creating a dummy seems to me the most logical way to begin developing a book, as it's then possible to see the flow of each spread, and decide if the individual images and page layouts work well together."

Begin's thumbnail sketches are generally quite small and lacking in minute detail. "It's all about shape at that point, and the basic issue of how things are aligning," she says. "I ask myself, 'Does it feel like it should be a long book, or a tall book. Should it be formal in its design, with borders, or should it run off of the page as a full bleed?'"

5.

5. Victorian reference image from *A Victorian Scrapbook* by Cynthia Hart, John Grossman, and Priscilla Dunhill (Workman Publishing, 1989).

6–9. Final art from the first two
Willow Buds books.

Dear Reader,

I found this really old suitcase in my grandma's attic that belonged to my great-great-uncle Ratty. Inside, I found a set of diaries and a little key. The diaries were filled with funny stories about Uncle Ratty when he was young and just getting to know his pals Badger, Mole, and Toad, who you might know from *The Wind in the Willows* by Kenneth Grahame. The book describes their adventures as grown-ups, but nobody ever knew how they became friends. I asked my friend Mary Jane to retell the stories from Uncle Ratty's diaries. She even called them Willow Buds–in honor of my name! Here's the key to each of the books . . . I hope you enjoy them!

Your friend,
Rose Bud

For her final format choice, Begin wanted the Willow Buds books—each of which opens with a letter from a narrator named Rose Bud (see left)—to feel like an old diary with a key, just like the ones her grandmother used. "The books are meant to be the right size for children's hands, and small like a diary. It's strange that I've written a prequel to a story that's a century old—a series of new books whose action happened earlier than the original story, and where the characters are telling stories about their childhood from the age that the animals were in the original book. I enjoyed the time warp when writing the stories, and by using a diary as a format I tried to explore that paradox. Like diaries themselves, I wanted to be able to capture time, and move seamlessly in and out of this imagined history."

The art process

Studying the artwork of Victorian-era postcards, advertisements, book work, and design, Begin sought to capture both a vibrant energy to the color and softness of vignettes to translate the Victorian style, but still hold true to her own color sense and methods. She played with contrasting opaque watercolor in highlights against transparent watercolor in the lowlights of objects—using an egg tempera-like series of brushstrokes to build the paint on the surface of the paper.

10.

10. A letter from Rose Bud and the key.

"I used pastel over fully dried watercolor for skies and vignettes, trying to capture the Victorian palette and style achieved originally by artists of the period with mainly watercolor and inks," she says. "My method allowed for a more dimensional feel—akin to acrylics or oils—as I am intrigued by the way in which the illusion of light can be used in designing a page and creating a mood."

Begin chose Canson artist paper because it can be stretched like watercolor paper and is durable for layers of media, and she used a variety of Winsor & Newton and Cotman brand paints. "I enjoy cooking, and I compare the mixing of artistic materials to the experimentation and creation of new recipes," she says. "You might make a few duds, but it's completely worth trying to invent a personal language with the elements and ingredients at hand."

Begin studied Victorian-era artwork and design...

11.

11–12. In-progress art from Willow Buds.

12.

13.

Alison Impey on book design and typography

Alison Impey, a senior designer at Little, Brown and Company Books for Young Readers in New York City, worked with Mary Jane Begin on the Willow Buds series. Impey explains:

The designer is responsible for packaging the book. An effective design carries through from the jacket and case to the fonts chosen. To open a book is an experience, and the design should enhance that.

Myself, Mary Jane Begin, and the book's editor wanted the Willow Buds books to feel like little treasures, and we chose a smaller than standard trim size of 8 × 6$\frac{1}{2}$in (20.3 × 16.5cm). For the cohesiveness of the book, I selected fonts that were reminiscent of the Victorian era, and I even found some authentic Victorian letters that I used for the initial caps. The first book is set in the spring and the second in the fall, so I complemented the colors of the initial caps with those of the seasons: green and red, respectively.

Selecting the font size and leading (the space between lines of text) and deciding how to break the lines is important. When looking at a spread, it should feel visually balanced. In other words, the type needs to feel like it belongs and is not forced into a space. Much of this is worked out in the sketches, but spatial challenges can remain even in the final art. Some of the spreads have full-bleed art, while others have vignettes or text-only pages framed by an illustrated border. Inspired by the warm, cream-colored paper the artist painted on, I decided to print all the backgrounds, even the copyright and dedication page, in this cream color, which felt appropriately Victorian.

The cover design is crucial because it often determines whether or not the reader will pick up the book. For Willow Buds, I hired a hand-letterer to create a type treatment based on Mary Jane's original rendition for the series title. The idea was to have the letters look like willow leaves. I initially placed the tagline at the bottom of the cover, but it looked much too crowded with the author's name and the title. I decided to include the tagline in a leafy banner beneath the series title. We used gold foil for the artwork that frames the cover.

An added detail is the case design. When you remove the jacket, you find a different design, inspired by an old leather album, with corner pieces and a spine wrap. It's these small details, which may go unnoticed at first, that truly add to the enjoyment of the book.

13. Logo for Willow Buds series.

14–15. Covers for the first two Willow Buds books.

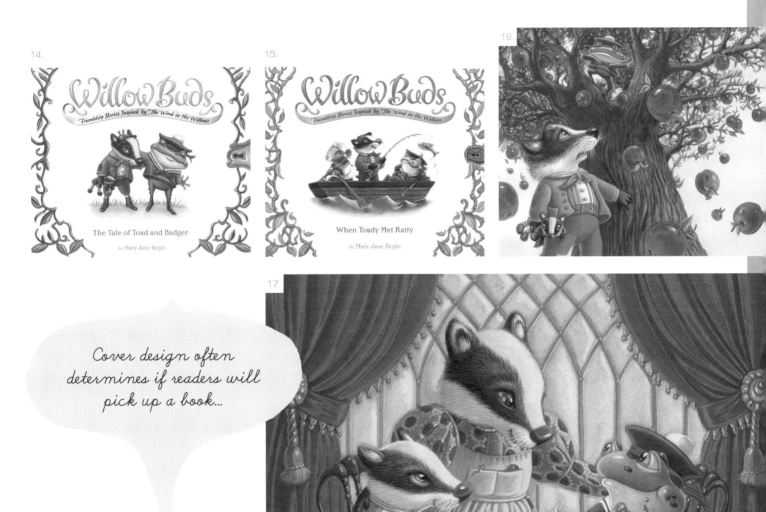

14.

15.

16.

17.

Cover design often determines if readers will pick up a book...

16–17. Final art from the first two Willow Buds books.

Mary Jane Begin on *The Sorcerer's Apprentice*

The inspiration for retelling and illustrating *The Sorcerer's Apprentice* came from an unlikely source: the decision by another illustrator not to illustrate it. A number of years back, a very well-known illustrator who was working with my publisher decided that the text wasn't right for his style and declined to take it on. My editor thought that I would be perfect for it and asked if I was interested. It meant creating my own version of the 1,800-year-old tale, and an opportunity to put my own spin on both the text and pictures—of course I said yes!

Traditionally, the tale was told as a moral about a young and lazy boy who wants to avoid hard work and learn magic to take care of his chores so that he can sit back, relax, and do nothing. The story provides grave consequences for such laziness, with the lesson being abundantly clear—chaos and near-disaster are the result of his foolish behavior.

For this retelling, I decided that the apprentice should be a girl from a well-to-do family who is eager to learn magic for the sake of exploring something that fascinates her, but is surprised that her "learning" consists primarily of doing laborious chores for the Sorcerer. The Sorcerer is cast as a type of father figure who decides that the girl needs to learn the "lesson" of working diligently and persistently to gain knowledge, and to recognize that learning something new is not always easy. The theme is a common one for parents, as children so often want to be "experts" at everything and speed past the apprenticeship stage that is so important for growth. The girl is eager to rush headlong into learning magic—because she wants to take care of her chores just as the master does, and casts a spell without knowing how to stop it.

I cast my daughter and husband as the main characters, and set them in the Renaissance—the time period when magic and mysticism were giving way to ideas of science and intellectual transformation. Although it is unlikely that a girl would have been given such an opportunity in that time period I felt that it sent a message to contemporary girls that patience and persistence, rather than reckless, impetuous decision-making, means mastery over their power, both as budding young women and brave intellectual explorers.

Begin on characterization

Some of the best characterization is defined by the silhouette or overall shape of a character—it describes the posture and personality and is the first element that we see. The early stage of development is all about describing that shape, blocking in pictorial space, and defining where the character begins and ends.

In an animation you have movement to help describe a personality, but in books you have a moment—a single image, or a series of still images—to capture the character's essence. Much design thinking has to go into deciding the final form: should the figure be symmetrical or asymmetrical? What element should be the largest shape? What is the overall gesture and mood of the character expressed? How will the facial expression (if it has a face!) define the mood? When drawing animal characters, anthropomorphism (attribution of human facial expression and gesture) can be used to explore character.

Being able to be emotive and expressive, to understand what the physical expression is of an emotion or an idea, is so important to executing the book and making it believable and accessible to the reader. It's a balance of two main components: the movement, gesture, or motion of the human body and the highly detailed structure of the human or animal body. I don't think any characterization is really compelling if it's entirely missing one or the other.

For my work, I tend to focus on details, so I have to push myself to find the gesture and proportions that best describe a character's true self. This happens mostly at the sketch stage, drawing many versions of the same character in a variety of poses and expressions. When I nail it—it's worth all of the broken pencil leads, blackened erasers, and cramped fingers to create a connection to the reader through a character.

Painting The Sorcerer's Apprentice

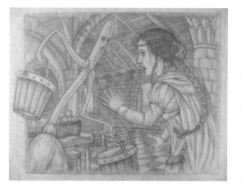
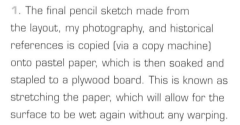
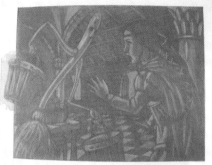
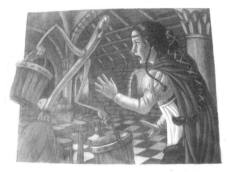

1. The final pencil sketch made from the layout, my photography, and historical references is copied (via a copy machine) onto pastel paper, which is then soaked and stapled to a plywood board. This is known as stretching the paper, which will allow for the surface to be wet again without any warping.

2. The surface of the pastel paper is covered with sienna pastel, and areas where light hits a form are erased or subtracted from the surface of the paper.

3. After the pastel is applied, the surface is sprayed with a workable fixative, and then acrylic and watercolor paint mixed with gloss medium is applied to the surface. The area to the right is more highly developed with layers of paint than the left side.

4. Several paintings are worked on at one time for efficiency as well as consistency of color.

5. Sketches are used as guides for the painting in progress, as the sketch on the painted surface is often obscured by the paint and pastel.

6. The finished painting for the page, which will include the text:
You've done your best, Now take a rest!
Stand by the door, As you were before.

7. The apprentice confronts the broom with a hatchet.

8. The finished painting shows the highest conflict in the story—the tension between the menace of the magic and the girl's inability to control it—stretching as a full bleed across the gutter.

Artist profile:

Shaun Tan

Country of origin: Australia
Primary format: Picture books
Primary techniques: Variety of media

Shaun Tan was born in 1974 and grew up in the northern suburbs of Perth, Western Australia. As a teenager, he published illustrations for science fiction and horror stories in small-press magazines. He graduated from the University of Western Australia in 1995 with joint honors in fine arts and English literature. His picture books have received numerous awards, including the Children's Book Council of Australia Picture Book of the Year Award for *The Rabbits* with John Marsden. In 2001 and 2007 he was named Best Artist at the World Fantasy Awards in Montreal and New York. He has worked for Blue Sky Studios and Pixar, providing concept artwork for *Dr. Seuss' Horton Hears a Who!* and *WALL·E*.

As a child, Tan drew and painted as often as he could, and his mother read George Orwell's *Animal Farm* to him and his brother (which directly influenced *The Rabbits*), among many other books. He vividly remembers *The Headless Horseman Rides Tonight* by Jack Prelutsky and Arnold Lobel, *The Mysteries of Harris Burdick* by Chris Van Allsburg, *Fungus the Bogeyman* by Raymond Briggs, *The Hobbit* by J.R.R. Tolkien, and anything by Roald Dahl and Quentin Blake. He also lists the Tripods Trilogy by John Christopher, the stories of Ray Bradbury, and numerous science fiction and fantasy films and TV shows as influences.

1.

1. Illustration reproduced with permission from *The Arrival* by Shaun Tan, Lothian Children's Books, an imprint of Hachette Australia, 2006.

"On leaving university, I became increasingly involved in children's and young adult literature, including picture books, largely because some of the writers involved with science fiction were also being published in this area as well," says Tan. "I knew very little about picture books when first asked to illustrate one, and tended to share many people's prejudice that they were exclusively the domain of young children, not an art form that lends itself to much artistic or intellectual sophistication."

As he began to investigate and experiment, however, Tan learned that picture books could be as sophisticated as any other art form. The text and illustrations, he says, "operate as narratives in isolation, but happen to react in similar ways, opening new meanings from each other's context. Illustrations are for me the main 'texts' in my books, and although writing is often the starting point, it rather acts as a kind of scaffolding or binding that stitches everything together. More recently, I have been thinking a lot about visual narrative where there is no accompanying text. I'm intrigued by the ability of the reader to superimpose their own thoughts and feelings onto visual experience, without the possible distraction of words."

2.

Creating *The Arrival*

While most of Tan's picture books have taken about a year to complete, his wordless book *The Arrival* took nearly five years. A riveting immigrant's story told through a series of beautiful sepia images that find a balance between realism and surrealism, *The Arrival* can properly be called a graphic novel. It has enticed both child and adult readers, and many critics have called it a "masterpiece" of visual narrative.

For Tan, a period of research—reading, looking at pictures, playing with different media—always precedes the actual writing or drawing. "Research provides freedom from the creative paralysis that comes with infinite possibility," he says. "I need specific points of reference to develop ideas, and also a kind of resistance to my own stylistic 'default settings' so that I can think outside the usual circles and actually learn something new.

"Painting and drawing for me is not about creation but about transformation. It's not so much about expressing preconceived themes or a mastered delivery of statements but rather a process of slightly absent-minded discovery, of seeing where certain lines of thinking take you if you keep following them. I know I'm on the right track when there is a sense of unfamiliarity about what I'm doing, that I'm actually being surprised by the way mixed drawings and words make their own novel sense, and I can coax them into surrendering whatever meaning is there through repeated

2. Cover reproduced with permission from *The Arrival* by Shaun Tan, Lothian Children's Books, an imprint of Hachette Australia, 2006.

3.

4.

drawings." Once the story and concept seem strong, and a publisher expresses interest, Tan produces a dummy. "The dummy is the 'instruction manual' for the finished artwork and story that I refer to throughout the long process of production, which can extend, on and off, over a period of years. During this time, the dummy serves to remind you of the look and feel of the project."

For *The Arrival*, Tan took rough drawings up to a quite finished point, and also combined these with photographs shot in his garage of people and objects. After redrawing everything in graphite pencil on A3 (30 × 40cm/11^{46}/$_{64}$ × 16 1/$_{5}$in) or A2 (40 × 60cm/16^{1}/$_{5}$ × 23^{13}/$_{32}$in) cartridge paper, he would then scan the black-and-white finished drawing and color it digitally using Photoshop.

Tan tries to give as much input on the design, layout, and typography of his books as possible. "The cover illustration is always the last thing I do, and I see it

3–6. Interior illustrations reproduced with permission from *The Arrival* by Shaun Tan, Lothian Children's Books, an imprint of Hachette Australia, 2006.

as the least important in terms of the story, though it's obviously significant in other ways. It's there to get the reader interested in what the book is about, especially by looking different or unusual. It needs to represent the whole story to some extent, as it is the image most readers will be exposed to when it appears on shelves, in any newspaper or magazine reviews, and even in a reader's memory. People do judge a book by its cover!"

Tan's advice to aspiring illustrators: "As long as you are doing something, even if it isn't successful, you are not wasting your time. The greatest achievement of so much creative work is simply finding time and dedication to do it, especially when it seems difficult and less than enjoyable (almost every project seems to involve some kind of confidence-wounding 'crisis'). Good ideas and talent aren't worth much if they're not put through the wringer of actual hard work. The main thing is to just get things finished, regardless of difficulty."

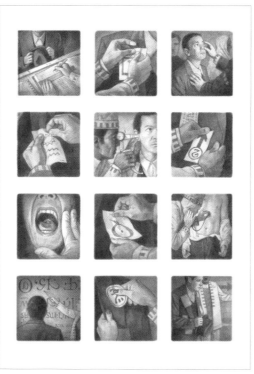

5.

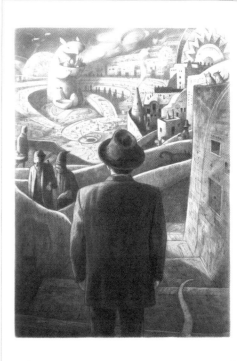

6.

Artist profile:

Brian Floca

Country of origin: USA
Primary formats: Picture books, comics
Primary techniques: Pen and ink, watercolor, pencil

Brian Floca was born and raised in Texas. He attended Brown University in Providence, Rhode Island, where he studied art history, cartooned for the *Brown Daily Herald*, and took classes at the nearby Rhode Island School of Design.

A RISD class with author and illustrator David Macaulay led to a collaboration with author Avi and editor Richard Jackson on what became the graphic novel *City of Light, City of Dark*. This led Floca on to more illustrating, writing his own stories, and an MFA in illustration from the School of Visual Arts in New York City.

His recent books include *Lightship* (which received the Robert F. Sibert Honor Book Award in 2008) and *Moonshot: The Flight of Apollo 11*, both written and illustrated by Floca. He has also illustrated *The Hinky-Pink* by Megan McDonald and *Poppy* and *Ereth's Birthday* by Avi.

In addition to his picture-book work, Floca also illustrates a regular comic feature called *Beatrice Black Bear*, written by John Grandits, which runs on the back of each issue of *CLICK* magazine.

1–2. "Liftoff" sequence from *Moonshot: The Flight of Apollo 11* proposal sketch to uncolored double-page spread.

Becoming an illustrator

Regular visits to the library played a huge role in Floca's life when he was young. Anything was fair game, but dinosaur books and books by Richard Scarry are what he remembers best. The first books Floca can remember making were in the second grade—he had several encouraging teachers—and were built, he says, around the adventures of the sort of superheroes that you imagine at age seven: "Anthropomorphic ducks, bionic melons, that sort of thing. Even at that age I knew that I loved both drawing and writing, but the idea of life as a professional artist was a long way off. Temple (Texas) was a good place to grow up, but it was not heavily stocked with working artists. I had very little context for thinking about what that kind of life might be like, or how it would work."

3–5. Progression of "zero gravity" scene from *Moonshot*.

Floca took art classes and wrote regularly when he was in school, but it wasn't until he pursued his master's degree in illustration that he had an "intensive" art school experience. "It's hard to say how important education is, as different people find different paths, but what was valuable for me about art school was that, whereas I had always been the one person in my close circle of friends who could draw really well, now I was surrounded by talented artists. That meant a lot of time bumping up against other people's strong work, which is a really useful way of learning about your own work."

Floca lists George Herriman, Winsor McCay, Charles M. Schulz, Bill Watterson, and Garry Trudeau as his favorite cartoonists. "As far as picture-book artists go," he says, "I most admire what I think of as the pen-and-ink and watercolor crowd: Quentin Blake, Edward Ardizzone, E.H. Shepard, Warwick Hutton, David Gentleman, and Robert Andrew Parker. I like to see both draftsmanship in a drawing and also the human hand, the scratches, and even the spills."

Working methods

Although he often arrives at and leaves his studio earlier or later than he would like, Floca does try to keep a regular schedule. "Flashes of inspiration are great," he says, "but steady work habits are essential."

Floca used to work from home, but admits it was making him "a little crazy." For the past several years he has rented space in offices with other freelancers, including writers, editors, architects, and lighting designers. "That's been great. We each work independently but benefit from the conversation and being around each other."

As for moving his art into the digital realm, Floca says, "I will occasionally scan a sketch if I want to try quickly resizing an element of it, or something like that. Of course, I use the scanner and the computer for my website and for sending scans of work to art directors and editors, so in that sense I'm using my computer for work all the time. But as far as the actual work is concerned, it's paper, ink, pencil, and pigment, which is how I like it."

6. Progression of "zero gravity" scene from *Moonshot*.

Floca on the "liftoff" sequence from *Moonshot*

In most movies and even in some documentaries, the liftoff scene gets edited so that the rocket's engines ignite at the end of the countdown: three, two, one, zero, ignition! At an actual launch, though, ignition occurs at around the nine-second mark. The engine thrust builds to full strength for the rest of the countdown while hold-down arms keep the rocket steady. Then, at zero, the arms release the rocket. I imagine that filmmakers alter the sequence so that the camera can spend more time with vivid images of the engines coming to life; those few seconds pass very quickly in actual, unedited footage. Time moves differently in a book, though, so I tried to use panels and page turns to stretch out the events, while staying true to how they actually occur: three, two, one, zero, liftoff! (see images 2–3).

Floca on the "zero gravity" interior scene from *Moonshot*

From earliest sketch to final art, almost nothing about the idea of this page changed. I knew I wanted an interior view of the Command Module, and to see the astronauts floating around in it. Books, diagrams, websites, and museum visits were needed before I could draw something that realistically resembled a Command Module interior, though (see image 6).

Panels and page turns can stretch out events.

6.

strong, Collins
ick gloves,
ick helmets,
lick the straps
hold them down,
float inside their small ships,
r home for a week.

e there is no up or down;
astronaut can spin in air and turn
oor into a wall
a ceiling to a floor.

d on those sometimes
ilings, walls, and floors—everywhere—
ere are straps and screens and gauges,
ttons, handles, hoses,
d switches, switches, switches.

here are food and clothes
acked into corners.
There are flight plans, flashlights,

Artist profile:

Polly Dunbar

Country of origin: UK
Primary formats: Picture books
Primary techniques: Pen and ink, watercolors, collage

1.

Polly Dunbar was brought up in Stratford-upon-Avon, UK. Her mother, the well-known children's author Joyce Dunbar, started writing when Polly was very small, and her father also illustrated for a time. "I was very lucky, as they used to show me their early ideas," she says. "I remember thinking the characters in their stories were actually real. I suppose I grew up thinking that making books was the thing to do."

Dunbar moved to Norwich with her family when she was 11, and at 17 undertook a foundation art course at Norwich School of Art and Design. At this point she wanted to be a painter and do a degree in fine art. "When it came to putting my portfolio together, my work was full of people and faces. The tutors frowned and told me that I was an illustrator, not a painter. So I went to Brighton University to study illustration… and to draw people! I spent a lot of my time at college coming up with cartoons with one line of text and one picture. I love the way the juxtaposition of the two can make something surprising and funny happen. I think this was when I realized I liked words almost as much as pictures."

Growing up around picture-book making was very helpful when Dunbar entered the publishing world. "With any creative path, things don't always go according to plan," she says. "You never know which ideas will work and which will be forgotten, or if you'll ever have another good idea again. It was great working with my

2.

1. Dunbar's workspace.

Dunbar fills pages with
as much color as possible...

mother. She started our collaborative book, *Shoe Baby*, when
I was at college, inspired by a picture I had done of a little girl
stepping through a sea of shoes. It was six years later that she
finished it. I had already written a couple of my own books by
then. It was never forced. We didn't have this great plan to
do a book together; it just popped up at the perfect time."

3.

2–4. Children's illustrations by
Polly Dunbar.

5.

Creative choices

When Dunbar starts to illustrate a book, she usually tries to fill the pages with as much color as possible. She often varies her working methods to suit the job at hand and to keep herself interested. In her book *Penguin*, for example, which was inspired by an old toy given to Dunbar by her brother, she used ink pen and watercolor washes. She finds Adobe Photoshop to be helpful for cleaning up images, and loves to use collage in her work. "There's a real freedom in using random bits of paper, and sometimes you can get exciting surprises," she says.

Dunbar spends a lot of time sketching her characters, getting to know each one well. Then she can draw them confidently and without thinking too much, with a much freer line.

"When I'm writing it can take months of tinkering before a story really works," she says. "I make many dummies, trying to get the flow and balance of the story just right. I don't think too much about the age range of the reader, as it can sometimes get in the way of the story and it's easy to talk down to children. I want my books to be amusing stories for everyone—children and their parents. It is always possible to simplify a complex idea after it has been written, making it more child-friendly. The most important thing is to write from the heart…and then worry about the other stuff later!"

5–6. Children's illustrations
by Polly Dunbar.

Piet Grobler

Country of origin: South Africa (now living in the UK)
Primary formats: Picture books and children's books (all ages)
Primary techniques: Wide range of media

Piet Grobler is one of South Africa's most revered illustrators for children and adults, and his work is known around the world. Born in 1959 in Nylstroom, Bushveld, in the Limpopo Province, Grobler grew up on a farm on the Springbok Flats as the eldest of five children, and spent much of his childhood playing with animals, drawing, and reading.

Grobler holds numerous degrees in various fields. He studied theology at the University of Pretoria and served as a reverend of the Dutch Reformed Church for five years, during which time he illustrated a series of bible and educational books. Grobler also obtained an honors degree in journalism and a certificate in graphic design, and has been a freelance artist and illustrator

2.

since 1996. His participation in the Bratislava Biennial of Illustration (BIB) in Slovakia was instrumental in his decision to follow a career in picture-book illustration and to earn an MA degree in fine arts (illustration).

Grobler has received a series of national and international awards throughout his career, including two silver medals in the Noma Concours for Picture Book Illustrations, the Octogone de Chêne prize, and a BIB plaque. Grobler has also been awarded the Katherine Harries award, South Africa's highest medal for picture-book illustration (in 2000–01, 2002–03, and 2004–05). He held two part-time posts teaching illustration at Cape Peninsula University of Technology and Stellenbosch University, and also ran a studio gallery called Hoi Hannelore! And Other Stories in Stellenbosch in the Cape Winelands. He now lives with his wife Marietjie, daughter Catherina, and dog Bella in Cambridgeshire, UK.

"My work for adults is mainly editorial or magazine illustration," says Grobler. "Thematically, and in terms of the content level, this work would naturally be different from my children's book work, but the different styles are definitely connected. I would

3.

1–3. Art from *The Ballad of Death (Ballade van de Dood)*, written by Koos Meinderts and Harrie Jekkers and illustrated by Piet Grobler.

like to mention, though, that even my paintings or fine-art work is of a narrative nature, and is stylistically typical or recognizable of my work overall.

"When I work on a picture book it is not as if I am trying to think or be like a child again. I do not buy that claim made by some illustrators. We have lost our innocence and can't ever be children again. I believe that my way of making images simply suits picture books for children. I work for (illustrate for) a text, not for an ideal child of some kind. I keep the text in mind, not some or other target reader or group."

Grobler's most successful book in terms of sales, reprints, awards, and translations is *Please Frog, Just One Sip!*, which is a retelling of an Aboriginal folk tale but with an African setting.

Grobler on South African children's books

The South African picture book industry is small. We don't have a big book-buying culture (except for some avid bibliophiles). By Western standards, few picture books are published each year, although having said that, South Africa is by far the most sophisticated and strongest picture-book environment on the continent. Picture books here are fairly Anglo-Saxon, but with a certain African flavor, and they are often decorative and perhaps feature bolder colors in comparison to some other English-speaking countries. South African picture books have only recently become a bit more experimental and less focused on realism and caricature. The strongest exponents would be Niki Daly, Jude Daly, Fiona Moody, Joan Rankin, and I suppose I would also be up there with them.

4.

4–5. Art from *The Ballad of Death (Ballade van de Dood)*, written by Koos Meinderts and Harrie Jekkers and illustrated by Piet Grobler.

Grobler on *The Ballad of Death* (*Ballade van de Dood*)

My most recent picture book, *The Ballad of Death* (*Ballade van de Dood*), was written by Koos Meinderts and Harrie Jekkers from the Netherlands. The unusual, poetic story concerns a king who unwisely orders his subjects to banish Death from his kingdom. Of course, Death triumphs in the end.

This is my second version of the book. The first effort had been completed four years ago. I did the whole book while I was going through a rather dark period of my life, and the illustrations reflected that. I used charcoal and collage, so the pictures were gloomy and slightly eerie. Jean Christophe Boele van Hensbroek, my Dutch publisher, felt he couldn't publish it. The text remained in my drawer until early 2008, when I started working on it again.

This time I decided to make all the characters animals instead of humans. When they were humans the idea of death felt too close to home. Animal characters, on the other hand, immediately transfer the narrative to the realm of fantasy, fable, or fairy tale, which makes the serious subject matter easier to digest. I used watercolors with Rotring graphic pens on white etching paper. The bright watercolors and delicate lines feel light and friendly, which is confirmed by the minimal background and white paper.

The focus is on the lighter side of the narrative. Even though the story deals with death, it is rather positive. One realizes in the end that it would be unbearable to live on this earth forever, so death becomes merciful, hence my choice of a white rabbit (a nurse) to be Death.

By using little symbols of different religions on the towers and choosing animals from different continents, I hope to suggest a theme of universality. The king's wise men have also been chosen with certain attributes of ministers and politicians in mind (e.g., a cunning snake, a loyal dog, a wise owl, etc.).

I think the fact that one illustrator can choose two completely different approaches to the same text is a clear confirmation that there is no one meaning of a text, but that meaning is brought to the text by everyone who interacts with it.

5.

Artist profile:

Thacher Hurd

Country of origin: USA
Primary format: Picture books
Primary techniques: Pen and ink, watercolors, digital

Born in Vermont and now living in California, Thacher Hurd grew up in a family of children's book artists. His father, Clement Hurd, illustrated such classics as Margaret Wise Brown's *The Runaway Bunny* (1942) and *Goodnight Moon* (1947), and his mother, Edith Thacher Hurd, wrote more than 75 children's books, most of them illustrated by Clement.

After he graduated from the California College of the Arts, Hurd began to turn his talents to picture books. He has written and/or illustrated more than 30 books, including *Mama Don't Allow*, which won the Boston Globe Horn Book award in 1985, *Mystery on the Docks, Art Dog, Moo Cow Kaboom!*, and *Bad Frogs*. He has also produced two board books for HarperCollins—*Zoom City* and *The Cat's Pajamas*, and is the coauthor of *Watercolor for the Artistically Undiscovered*. Hurd and his wife, Olivia, founded and ran Peaceable Kingdom Press for many years, until its sale in 2000 to The Booksource. They live in Berkeley, California.

"Even though I grew up in a family of artists," says Hurd, "I can't say that I consciously wanted to be an artist when I was growing up; baseball and rock-and-roll were my passions before art school. But I feel as if I learned so much by osmosis from my parents. When I was young, I would go to my father's studio and watch him work, or he would give me a pencil and paper and we would work together, so to speak. He was quietly supportive, and always gave me the feeling that I could do art, that what I did had value and meaning. My mother was the same way. I think I learned how to write just by being around her, by listening to her read, by taking in the way she thought about writing and what was important in a story. When I started making books after art school, I realized how much they had given me, and I am always grateful to them for that."

1.

1–3. Preparatory character art for *Bad Frogs*.

The birth of *Bad Frogs*

Bad Frogs was a picture book that had been rattling around in Hurd's mind for years. "It was a kind of picture-book opera at first, but over time it changed. I eventually discovered that by stripping it down to its minimalist essence it came alive for me: a raucous evocation of a three-year-old's idea of mischief and merrymaking—doing everything that you aren't supposed to do."

For Hurd, pictures are driven by the energy in the story, and are the servants of words, only coming alive if the words are full of life and surprises of their own. After he had worked out the text for *Bad Frogs* with his editor at Candlewick Press, the pictures took a long process of evolution to come into being.

"The basic difficulty was how to draw frogs that appear bad and mischievous, but that are, at the same time, sweet, innocent, and funny," he says. "I struggled with this for a long time and found that, eventually, after drawing frogs for months, their character started to appear. It was a lesson to me that I couldn't initially conceptualize the pictures; I just had to draw the characters, and then the drawing itself would bring out who they were. And, of course, they were intentionally drawn for small children. I think of my audience as basically three- to five-year-olds."

2.

3.

Hurd created the artwork using a kind of hybrid technique: about 80 percent was drawn on Arches watercolor paper with watercolors and India ink, and the other 20 percent was done on the computer, using a sort of digital collage technique. "I would do most of the composition on watercolor paper, then scan it into the computer and play with it a little bit in Photoshop (although not too much!), adding background colors and any other little tidbits such as weird photos that I wanted in the picture. These digital files were then sent electronically to England, where the Candlewick designer works, and we would go back and forth from there."

4–6. Preparatory character art for *Bad Frogs*.

Hurd's working methods vary from book to book. He has experimented with Photoshop and digital techniques, but has found himself slowly pulling back and using the computer as little as possible when it comes to doing the actual illustrations. "I've done the majority of my books on paper, and love the feeling of drawing on paper and the look of fresh, bright Winsor & Newton watercolor paint. No matter how good the scanner or how skillful the technician, digitally reproduced art just doesn't look as vibrant to me. I did have a lot of fun, though, doing the two little board books, *The Cat's Pajamas* and *Zoom City*, almost exclusively on the computer. They are shorter, and fell out in a more spontaneous way."

6.

Artist profile:

Rui de Oliveira

Country of origin: Brazil
Primary formats: Picture books, illustrations, design, animation
Primary techniques: Wide range of traditional media and techniques

Born in Rio de Janeiro, Rui de Oliveira studied painting at the Museum of Modern Art in Rio de Janeiro, graphic design in the School of Fine Arts at the Federal University of Rio de Janeiro (UFRJ), and illustration at the Moholy-Nagy University of Art and Design in Budapest, Hungary. He has also studied animation at the Hungarian Pannónia FilmStudio.

De Oliveira returned to Brazil in 1975 to work in television, and has been working as a freelance artist since 1983, creating book covers, logos, posters, animated films, and children's book illustrations. He is also a professor of visual communication at UFRJ, and holds a doctorate from the University of São Paulo.

Throughout his career, de Oliveira has illustrated all kinds of texts, ranging from the historical to the poetic, and by authors as diverse as Christopher Marlowe, Victor Hugo, Michael Ende, and a variety of Brazilian writers. International awards for de Oliveira's children's books include second prize in 1980 for the Noma Concours for Picture Book Illustrations, followed by several awards from the Brazilian section of the International Board on Books for Young People (IBBY), and he received

1.

2.

1. From *Fausto (Doctor Faustus)* by Christopher Marlowe, adapted by Luiz Antonio Aguiar and illustrated by Rui de Oliveira.

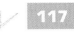

3.

a nomination for the 2009 Astrid Lindgren Memorial Award. In 2006 and 2008, he was the Brazilian nominee for the Hans Christian Andersen Awards in the illustrator category.

De Oliveira particularly admires the books of Walter Crane. "I think that the picture book originates from him and is, in my opinion, the greatest example of book art. Going even further back in time, I would mention William Blake as a great precursor of this genre. The picture book is not an opera; it is an operetta. It is not an orchestra; it is, at most, a quartet. The picture book is, for a child, an expression of intimacy."

Among notable Brazilian writers and illustrators for children, he admires the work of Angela Lago, Roger Mello, Graça Lima, Marilda Castanha, Odilon Moraes, Salmo Dansa, Jô Oliveira, and Andre Neves.

2. From *A Bela e a Fera (Beauty and the Beast)* by Rui de Oliveira.

3. From *A Tempestade (The Tempest)* by William Shakespeare, adapted and illustrated by Rui de Oliveira.

Two books, two approaches

De Oliveira often creates books with text or legends that are separate from the images or devoid of words. In *Chapeuzinho Vermelho e outros contos por imagem* (*Little Red Riding Hood and Other Tales*; written by Luciana Sandroni), the text is only a reference for the visual narrative. "My intention was to represent, as faithfully as possible, the social origin of those fairy tales, which were about the hard lives of peasants during the Middle Ages," says de Oliveira. "I also aimed to make a counterpoint to the glamorized and 'politically correct' versions (e.g., those of Charles Perrault), that in the long run became the official versions."

A second book, *Romance sem Palavras* (*Novel Without Words*) is narrated solely by images, and presents variations on Brazilian folk tales. "I have used a style in my drawing that I have been practicing in my sketchbooks for a while. I used the so-called universe of courtly love as a reference. I especially like the stories of King Arthur, Guinevere, Camelot, and the Knights of the Round Table," says de Oliveira.

The techniques used in these two books were completely distinct from one another. "I think that the words determine the technique I am going to use, and everything originates from there," says de Oliveira. "To picture the harshness of peasant life and the dark aspect of the woods in *Little Red Riding Hood*, I opted to work with chalk, graffiti, and crayon to emphasize the contrasts, textures, and light and dark sides of the characters and scenery."

4.

4. From *Um Herói Fanfarrão e sua Mãe bem Valente* (*A Notorious Hero and His Brave Mom*) by Ana Maria Machado, illustrated by Rui de Oliveira.

In terms of style and approach, de Oliveira sees illustration as similar to acting. "We interpret different roles, and for that we need to develop a space to detach ourselves. This in no way means a lack of personality, but rather just the opposite—the illustrator's personality is based on contradiction, not in coherency of style. I see the text as a musical score. How am I going to interpret it? I see style as a unilateral process, which means that the illustrator comes to the text with their visual repertoire ready to be used, regardless of the writer's genre and literary intentions. In other words, over time the illustrator learns to develop their own style. The approach is to understand the text first and then learn how to draw what is suitable. I believe—and this is a personal opinion that I have developed over the past 30 years—that the illustrator's veracity does not consist of the constancy of graphic solutions, but in the adequacy to the text, where the illustrator contradicts or denies themselves in each book."

5. From *O Pequeno Pássaro com Frio* (*The Little Bird's Cold*) by Assis Brasil, illustrated by Rui de Oliveira.

6. From *O Touro da Língua de Ouro* (*The Bull and His Golden Tongue*) by Ana Maria Machado, illustrated by Rui de Oliveira.

7. From *Cartas Lunares* (*Moon Letters*) by Rui de Oliveira. All images © Rui de Oliveira.

Artist profile:

Miriam Latimer

Country of origin: UK
Primary format: Picture books (for young readers)
Primary techniques: Acrylics, collage, pencil, pastels

Miriam Latimer grew up in Hertfordshire, England, where she loved creating anything and everything, from pictures to assault courses for her hamster. At 17, she undertook a foundation art course at Middlesex University in London, and then went on to do an illustration degree at the University of the West of England, Bristol.

Latimer has written and illustrated three of her own stories, *Wheelie Girl*, *Shrinking Sam*, and *Emily's Tiger*. She has also illustrated seven other books for publishers including Hodder, Barefoot Books, Kingfisher, and Ladybird. Her main artistic influences are Anne Herbauts, Sara Fanelli, Lauren Child, and Pablo Picasso. "I also love most French picture books; they are so quirky and interesting," she says.

Latimer lives with her husband by the sea in Devon, UK. "We live in a house on a hill that has great views. Perfect for daydreaming up new ideas. However, my studio looks out over this view, so I normally find myself staring out of the window a little too much."

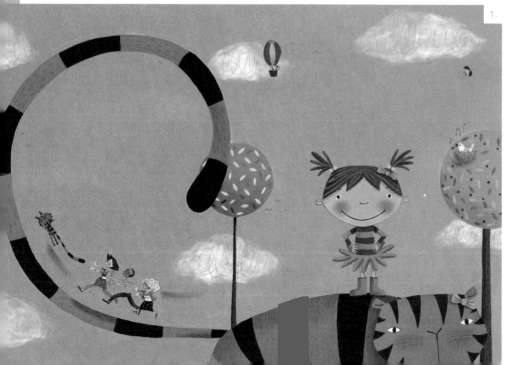

1.

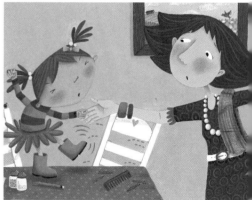

2.

1–4. Spreads (with text removed) from *Emily's Tiger*.

A bright color palette emphasizes tiger stripes and contemporary interiors...

Emily's Tiger, for ages four to six, is about a little girl called Emily who has trouble controlling her temper. Her anger takes over, and before she knows it she has turned into a naughty little tiger. It's not until her Granny comes to visit that Emily learns how to be a happy tiger instead of an angry one.

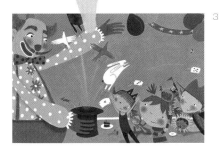

3.

"The story came about through talking to a friend who works with children with behavioral problems," Latimer says. "She commented that there were no books that dealt with controlling anger for children. I had dreamt up the idea of a boy who turns into a tiger at the time, so I thought I could marry up the two ideas. The little boy turned into a little girl somewhere along the line."

4.

Latimer mostly used acrylics when illustrating the book, but also employed some collage, pencil, and pastel techniques. "This is my usual process when illustrating, although I would say my work is becoming increasingly brighter in color due to publishers requesting it to be so."

Latimer began by drawing Emily's clothes, mannerisms, family, and friends, which helped to develop her character and personality. Most of the story then came out of the drawings. "The hard part is writing the story in a succinct way," she says. "Luckily, Tessa Strickland, cofounder of Barefoot Books, helped me to edit the text and gave me helpful ideas to include in the story."

Latimer tried to trap the text within the illustration as much as she could so that it felt like part of the illustration. "There are some instances when Emily roars, and the word 'ROAR' comes out of her mouth at an angle in capitals, which helps to illustrate volume. In this way, the text and illustrations work together; they complete one another."

Remarking on the current state of children's literature in the UK, Latimer says, "There are so many children's books out there now. We have been able to publish such a large number of children's books over the last few years that we are a little bombarded with choice. There are books about anything and everything. There is a real trend for eco-friendly books at the moment, books about recycling and caring for the planet. Most people I know want to read books to their kids that inspire their imagination."

Latimer's advice for aspiring illustrators: "Be confident in your work, and show it to as many publishers as you can. Be fairly flexible about changing little aspects of your work here and there, although it's very important to defend your work if they want to change it too much. Make sure you keep to deadlines and answer e-mails. If you find it hard to promote yourself, look for an illustrators' agent whom you get along well with. They can then do all the running around and promoting for you."

5–7. Spreads (with text removed) from *Emily's Tiger*.

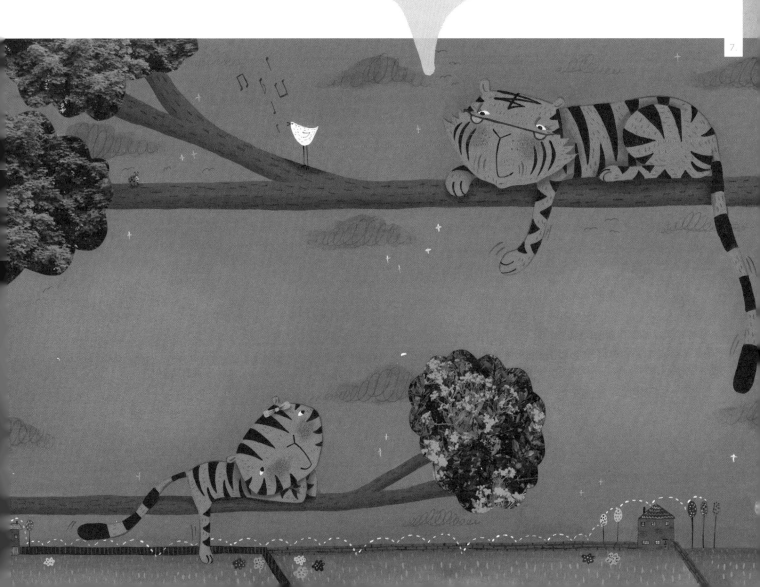

Nicole Wong

Country of origin: USA
Primary formats: Picture books and educational books
(for young and middle-grade readers)
Primary techniques: Pen and ink, gouache, digital

A soft color palette emphasizes the natural setting for Max's adventure...

1.

Nicole Wong was born in Fall River, Massachusetts. Her father was a designer and painter, and her mother was a fashion illustrator and art teacher. Wong never thought of becoming anything other than an illustrator, accepting her first freelance job when she was 12. Ten years later, she graduated from Rhode Island School of Design (RISD) with a BFA in Illustration. She dedicates her time to exploring different media and techniques, such as collage, photography, and egg tempera painting. She is a full-time illustrator of magazine and children's educational and trade books, and also a teacher in RISD's continuing education program.

One of Wong's favorite picture-book illustration projects is *Maxwell's Mountain*. Written by Shari Becker, this 32-page book, meant for ages four to eight, tells the story of a young boy who trains himself to climb to the top of a "rocky mountain" in a park near his home. Though the mountain doesn't have snow-capped peaks in the stratosphere, it nonetheless poses its share of dangers that Maxwell must study for. Building up his physical endurance, and learning the strategies of an outdoorsman,

2.

3.

1–4. Artwork from *Maxwell's Mountain*

Maxwell puts his preparations to good use and faces challenges one step at a time as he climbs to the top. "It's a bit of a coming-of-age story for a five-year-old," Wong says. *Maxwell's Mountain* was named a Junior Library Guild Selection title in 2006 and also made the Charlotte Zolotow Highly Commended Title list in 2007.

Wong began the illustrations by overlaying vellum on her sketches and inking with fine quill and Rapidograph pens. She scanned the images and adjusted them using Adobe Photoshop, and then printed the drawings onto watercolor paper using a large-format printer. She painted in thin layers of gouache, with a limited palette of yellow, red, brown, and blue-black. "I work a bit like an assembly line," she says. "The process moves along in its proper stages: sketch, ink, scan, print, paint. They all begin and end pretty much at the same time."

Like many illustrators in the world of children's publishing, Wong had no communication with the book's writer. She worked solely from the manuscript and with her art director, Susan Sherman. "The translation of words to images is what I do and how I think," she says. "Sometimes the images need to follow the story directly, such as a line that says, 'the character wears a yellow coat.' Other things need to be elaborated on or expressed through the images, such as Max's sidekick, Harry the toy soldier. The text never says exactly how Harry and Max interact, so I decided to give Harry a bit more life than a toy would usually have."

Wong's other picture books include *R is for Research* written by Toni Buzzeo; *My Grandpa Had a Stroke* written by Dori Hillestad Butler; *L is for Library* written by Sonya Terry; *Imagine a Rainbow* written by Brenda Miles, PhD; *Always My Grandpa* written by Linda Scacco; and *Candy Shop* written by Jan Wahl.

Expert commentary:
Susan Sherman

Susan Sherman has been designing children's books since 1977. She is currently Art Director at Charlesbridge Publishing in Watertown, Massachusetts. Over the years, she has been Art Director of Children's Trade Books at Houghton Mifflin, Creative Director at Little, Brown and Company, and has also run her own graphic design business, Ars Agassiz. She has taught the Radcliffe Publishing Course, been a member of RISD's Illustration Department Thesis Review committee, and given workshops on children's book illustration at the Maine College of Art and the University of Southern Maine. Throughout her career she has been fortunate enough to work with some of the most well-known illustrators and authors in the field.

Caldecott and Newbery books designed by Susan Sherman
1984 Newbery Honor Winner: *The Sign of the Beaver* by Elizabeth George Speare; 1986 Caldecott Medal Winner: *The Polar Express* by Chris Van Allsburg; 1989 Caldecott Honor Winner: *The Boy of the Three-Year Nap*, illustrated by Allen Say with text by Diane Snyder; 1990 Caldecott Honor Winner: *Bill Peet: An Autobiography* by Bill Peet; 1990 Newbery Medal Winner: *Number the Stars* by Lois Lowry; 1991 Caldecott Medal Winner: *Black and White* by David Macaulay

What is the art director's role in children's picture-book publishing?

The art director and the editor discuss the book—the author's intent, the age level the book is aimed at, and the audience—and they think about art styles together as they choose the artist to do the book. After reading the manuscript and having initial discussions about the book (much of this happens organically during the acquisition process), I present several portfolios to the editor for discussion. In the best of all possible worlds, the art director is also the designer of the book (I'll use the two titles interchangeably here). This avoids the "too many cooks" syndrome, allowing for a nice continuity in the book's design, art direction, and final production. Some artists want to have input on the design, trim, page grid, and typeface selections. The designer is usually the prime contact the artist has with the publishing house, through telephone calls, e-mail, and in-person meetings as the book is planned and executed. Depending on the artist, the art director/designer will adjust their way of working to accommodate the artist. It's this kind of variety that makes each book so interesting to work on. Every project is a new book, but also a new relationship to develop.

The designer then creates a "getting started" package for the artist that includes typefaces, page and jacket layouts, and any production instructions, such as electronic art requirements and ideas for art preparation, papers, and paints. I used to work in art supply stores, so I have a lot of material information for artists and can sometimes help them solve technical problems

by recommending paints, papers, or computer techniques. An accompanying letter also explains what it is about the artist's work that makes them the right person for the job, be it palette, design, characters—whatever aspects of their art that seemed right for the book.

The artist then sends in sketches—sometimes for the whole book at once, sometimes character sketches and ideas before they embark on an entire dummy. These mostly come by e-mail these days. Sketches are put into the page layout mechanicals and reviewed by the editor and art director—at many companies they are also reviewed by representatives from the marketing and sales departments. There is a dialogue with the artist that usually results in some revisions. This can range from reminders to leave room for type, to more conceptual questions about pacing and content, to specifics about consistency of color in a character's shirt, etc. This is when the diplomatic abilities of the art director are extremely important, as they must explain what is and isn't working, and to let the artist solve any problems.

What qualities do you look for in a picture-book submission or artist's portfolio?

First, I'm looking for someone who has basic technical ability. They need to be able to draw—they don't have to be a Rembrandt, but every illustrator/artist has to be able to create a competent world peopled with appealing characters. Most children's books are modern stories about "real" kids. Despite the popularity of fantasy, it isn't the most common genre and tends to be for older readers.

Second, the pictures have to tell stories; they need to be intriguing and interesting to look at. That leads me to the third, but perhaps most important, point, which is that I am looking for an artist with intelligence. The artist will be reading a stack of plain, typed pages—or an e-mail—and as they read ideas and images need to be forming in their heads. I am always looking for someone who can go beyond the obvious to create illustrations that extend the messages the author has written. The best illustrations surprise and delight with what they've brought to the whole.

What advice would you give to a new artist?

An illustrator who doesn't write is faced with a difficult problem: if they do too many books in a year they can flood the market with their work, and if they do too few, they starve. I recommend erring on the "too many" side, though. I have seen a few folks become forgotten when they didn't produce enough work.

A website/blog presence is essential these days. It needs to be fast-loading and have new work added at least a few times a year. Add a photo of yourself along with biographical information. Also, school visits are a great way to self-promote. I love postcards in the mail; they are quick to look at, and I can tell easily if I want to see more. Two or three mailings a year are enough to keep you in the forefront of an art director's mind.

Digital Dreams

Vectors and bitmaps

Picture-book illustrators who decide to work with digital tools will inevitably discover many powerful benefits, as well as some definite limitations, of digital image files, which divide into two primary types: vectors and bitmaps.

A simple way to describe the key difference between vectors and bitmaps is to say that bitmaps are composed of a grid of pixels (picture elements; tiny dots of individual shade or color) that combine to form an image, while vectors are composed of mathematically defined paths.

Bitmaps, which are resolution-dependent and lose image quality when made larger or smaller in size, include all images that are scanned, as well as those imported from a digital camera. By comparison, vectors must be created in software such as Adobe Illustrator or CorelDRAW, unless they are converted from bitmap images that have been traced or "vectorized." A vector can be easily converted to a bitmap, but in doing so, you immediately sacrifice the vector's scalability and resolution independence.

Many artists combine vectors and bitmaps in one image.

1. Vector image created in Illustrator.

Scaling a bitmap to a larger size ordinarily causes a jagged appearance when viewed onscreen at 72ppi (pixels per inch). This can be minimized by saving the image at a higher resolution and using anti-aliasing—where a program such as Photoshop gives the appearance of a smooth border by adjusting the subtle transitions in shading between pixels at the edges of text or a graphic. Vector images need no anti-aliasing and always render at the highest quality.

Unlike vector images, bitmap images are restricted to a rectangular shape and do not support transparency (except in .gif and .png formats for the web). Vector objects can be placed over other objects, and the underlying object will show through.

It is important to note that vectors and bitmaps are not mutually exclusive, and many artists combine both file types in a single illustration (see pages 134–135 for information about Smart Objects).

2. Vector detail.
3. Bitmap detail.

Workthrough: Vector illustration

Here we will show the most basic steps to create a character drawing in Illustrator, a popular vector application. A useful reference book for in-depth information about creating vector art is *Vector Graphics and Illustration* by Jack Harris and Steven Withrow.

1. First, make the bear's head from the circle shape. Illustrator offers basic shapes for use such as a square, rectangle, circle, hexagon, and star.

2. Begin to draw the bear using the line tool, which allows you to draw freely. All shapes need to be closed (without any gaps in the outline) so that they can be filled with a color or pattern.

3. Continue to draw the bear with the shape and line tools, creating the eyes, nose, and mouth. Each object can be moved forward or backward on different layers. Make sure that the eyes, eyebrows, nose, and mouth are in front of the head shape. This will help when adding fills and colors to the shapes.

4. Use the line tool to draw the bear's arms and legs.

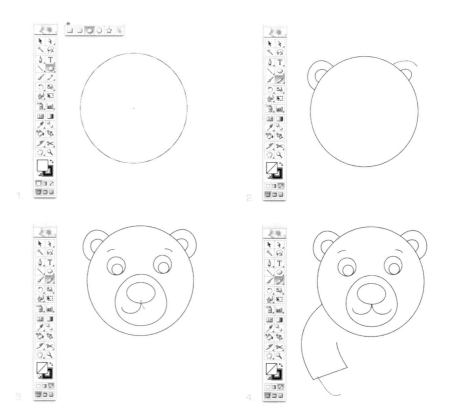

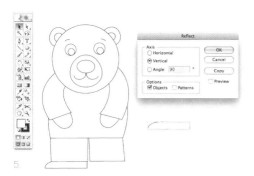

5.

6.

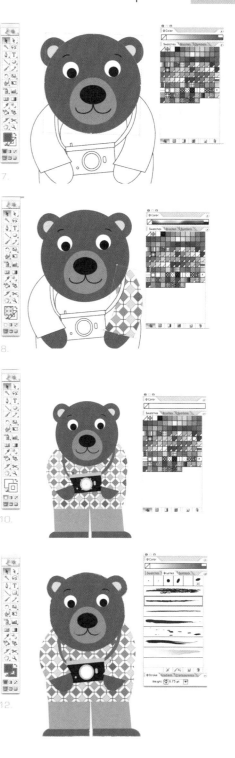

7.

8.

9.

10.

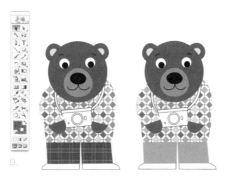

11.

12.

5–6. Draw one foot, copy it, and then reflect the copy at a 90-degree angle (select Object>Transform>Reflect and add 90 degrees in the dialog box) so that it faces the opposite direction. Any object can be rotated in any direction.

7. Add the color fills to the shapes. You can do this as you create each shape or once your drawing is complete. Add the brown color to the head as well as the black and white colors to the eyes and nose. You can also color the lines around a shape.

8. Use a standard pattern from Illustrator's Swatches palette for the shirt. There are many patterns to choose from to add visual interest to your art.

9. Here are two examples of some different fills for the pants. The red one is a different swatch pattern, and the green one is a basic color.

10. Finish the color on the bear. You can move the images forward and backward by selecting Object>Arrange>Bring to Front or Object>Arrange>Send Backward.

11. Add a fuzzy texture to the line work on the brown parts of the bear by using one of the standard brushes. Adjust the weight or thickness of the stroke (user-applied attribute that determines the style of an object's outline) until it looks right.

12. Finish by adding the same texture to the bear's snout, nose, eyebrows, mouth, arms, and feet.

Workthrough: Incorporating textures

The traditional techniques of cut-paper and mixed-media collage are mainstays of contemporary picture-book illustration. Much of their effect derives from creating surface textures that add palpability and dimensionality to an image. Digital artists using scanned and/or digitally created objects and patterns have a distinct advantage over traditional artists, in that digital files are simpler to manipulate and the range of creative options is, arguably, much wider.

Here we demonstrate a basic workthrough that begins with a 2-D vector drawing created using Adobe Illustrator, which is then imported into Photoshop for texturing. Illustrator, a dedicated tool for creating flat, graphic imagery, produced noticeably "cleaner" results than drawing in Photoshop, and Photoshop offered us much greater flexibility for texturing than Illustrator.

1. Initial vector drawing
The vector drawing (created using the pen, shape, and brush tools in Illustrator) serves as a sort of underpainting for the finished work in Photoshop. We imported the vector file (.ai) into Photoshop as a bitmap file (.psd). Photoshop gives the option of saving vector graphics as Smart Objects, which retain their vector scalability. However, Smart Objects are not editable, and since we wanted to be able to alter the images easily, we opted to save the vector file as a simple bitmap file.

2. Add textures and patterns
Textures and patterns can be sourced from found objects such as buttons, fabric, wood, stone, or paper that are scanned, imported, and placed as a unique layer. We scanned a handpainted texture to add a tint to all three bee characters. We used the filters under the Layers palette to adjust the texture map so that it looks transparent. We then adjusted the opacity to achieve the effect we desired. (Here, we used the color burn filter at 100% opacity.)

3. Using scanned ledger paper
We used the screen filter, adjusted the opacity to 45 percent, and trimmed the texture to fit the bee's body.

4. Adding accents using
Photoshop brushes
We also added a texture to the bee's stripes using the same texture from Step 2.

5. Using another scanned pattern
We repeated the order in Step 3 for a more ornate pattern.

6. The completed image
The decorative bees are now ready to take their place on the lush background.

Joanne Dugan on photographic picture books

Joanne Dugan is a New York City-based photographer, author, and creative director who uses city streets as her inspiration. Her fine-art images have been exhibited in the USA and internationally, and her assignment work has brought award-winning commissions ranging from individual portraits to images for global companies. She is on the faculty of the International Center of Photography in New York City and the Fine Arts Work Center in Provincetown, Massachusetts. Dugan is the author of ABC NYC: A Book About Seeing New York City, *and its sequel,* 123 NYC: A Counting Book of New York City.

ABC NYC started as a personal project to help me teach my young son the alphabet. As I wandered the streets of New York City with my camera, I realized that amazing alphabets were right there in front of us. I began photographing and creating archives of images, just for fun. I found new inspiration everywhere I looked and in every minute that we were roaming the streets together. I was especially motivated to have the project published after September 11, 2001, as I wanted to give something special back to my city that had suffered so. Also, I like making books that are ostensibly for children but are also equally appealing to adults.

I've been fascinated with the tradition of photographic children's books for years. Edward Steichen's *The First Picture Book: Everyday Things for Babies* is a treasure, and also plays on the idea of increasing children's awareness of their daily life

1.

existence. Tana Hoban was the grand dame of photographic books for children, and I certainly consider her an influence. I have personally tried to up the ante for the overall quality of photography in children's books, which I feel has sometimes been subpar at best. I'd like to think that my years as a serious

1. Cover of *123 NYC: A Counting Book of New York City.* **2–3.** Spreads from *123 NYC.*

working artist and photographer help bring a new dimension to the creative potential and quality of my books.

I think cost and quality are two major factors working against photographic books for kids. An illustrator's work is more about time than materials, and photographers have always had to struggle with costs. The good news is that now the photo world has gone digital, from a cost perspective, images can be made that are in line with illustrations.

I do actually see a resurgence in this area as the technology changes and continues to improve. I think there are many possibilities for great children's books that use photographs. It's important to remember that making quality, innovative, technically excellent images must always be a first priority for any author/photographer. Great photography is not simply the result of having a nice camera. It's about honing your technical skills to match your creative vision, and this can take some time.

Children have been wonderful with the books. I learn new things about my own books every time I read them to a child. I believe that kids interacting with photography books have a different experience than they do with illustrated books because the work is more based in their own reality, rather than in their imaginations. I love great illustration and would never want to see that go away, but I also feel that kids love to see what they themselves already know, and photographs can communicate this beautifully.

7 Helmets
Stop, drop, and roll!

12 Clocks
Count the numbers from one to twelve!

Artist profile:

Bridget Strevens-Marzo

Country of origin: UK (now living in France)
Primary format: Picture books
Primary techniques: Acrylics, brush and ink, gouache, digital

Bridget Strevens-Marzo has devoted her life to the promotion and progression of children's literature, and the picture book in particular. Born and raised in London, England, she now makes her home in Senlis, France, teaches at Parsons Paris School of Art and Design, and serves as Illustrator Advisor to the Society of Children's Book Writers and Illustrators. She has illustrated books for Editions Bayard, HarperCollins, Little Hare Books, Simon & Schuster, and Tate Publishing.

From very early on, Strevens-Marzo drew and painted alongside her artist father John Strevens in his London studio, and studied his collection of illustrated books by Edmund Dulac, W. Heath Robinson, and Arthur Rackham. She also loved E.H. Shepard's *Winnie-the-Pooh* drawings and the popular British *Rupert Annual* comic. "Traveling with my parents in the US introduced me to an inspiring new world of books by Margaret Wise Brown, Alice and Martin Provensen, Mary Blair, and other wonderful Golden Books artists," she says.

After studying Chinese and Art History at King's College, Cambridge, painting at École des Beaux-Arts in Paris, and copying old masters at the Louvre, Strevens-Marzo translated art history books. "I slowly found my own way to writing and illustrating my first three picture books, which were published by Little, Brown Book Group in the early 1990s," she says. Storyboarding for a Paris multimedia company added knowledge

1. Strevens-Marzo's studio.

> *Traveling introduced Strevens-Marzo to the world of books.*

of graphics tablets to her tool set, as well as more ideas for books and new clients to illustrate for, including French children's magazines.

A commission to illustrate Margaret Wild's *Kiss Kiss!* allowed Strevens-Marzo to develop a more painterly approach. She has continued to work for French publishers, often using the simplified graphic approach exemplified in *The Big Book for Little Hands,* co-written with Marie-Pascale Cocagne, which was on the 2007 British Book Design and Production Awards shortlist. Strevens-Marzo also illustrated Philemon Sturges's *How Do You Make a Baby Smile?*, which earned her a place in the Original Art Show at the Society of Illustrators in New York in 2007 and a listing in the Bank Street College of Education Best Children's Books of the Year for 2008.

"Each book I have done has demanded something different of me, although what they all have in common, so far, is their relevance to younger children," she says. "Of all design elements, it's color that leads me on, and I teach a course on color at Parsons Paris School of Art and Design. I have a collection of children's, artist's, and comic books, and share my wide interests at conferences run by the Society of Children's Book Writers and Illustrators. I'm also honored to be a member of the SCBWI International Board of Advisors."

2–3. Rough cover and character sketches from *How Do You Make a Baby Smile?* by Philemon Sturges, illustrated by Bridget Strevens-Marzo. Medium: brush and ink.

Or like Mama Elephant, wiggle your ear,

4

Getting the animal expressions right took some work...

Philemon Sturges's poem in *How Do You Make a Baby Smile?* addresses the reader, as the title suggests, and shows a diverse selection of animals using their best tricks to make their babies smile, laugh, coo, and grin. "When I first read the text, I felt it had to work both as a book for babies with strong, surprising images, and for children up to five or six who would be attracted by the rhythm and rhyme," Strevens-Marzo says. "I decided to show a glum human baby isolated at the outset, and then, rather than include human parents as the poem returns to the first question, I included an older sister, just to bring it closer to a five-year-old's world, and I show Baby's changing reactions to her as they interact over a couple of spreads."

Getting the animal expressions right took some work, and often it was as much about gesture as facial expression. "Another problem was how to create a link between a human baby and animals in very different natural habitats. My solution was to have Baby cuddle up at the end with toy versions of all the real animals shown in the book."

5.

6

4–8. Character sketches from *How Do You Make a Baby Smile?* by Philemon Sturges, illustrated by Bridget Strevens-Marzo. Medium: brush and ink.

Adapting the process to the project

Strevens-Marzo admits she does not have a standard creative method. "Every book I illustrate is a new departure for me. The subject dictates the approach. I have always loved brushwork in oils and gouache, often refining shapes by painting into them and finding the contour between two forms rather than using a line."

For this book, however, she drew all the outlines in ink and kept the lines fresh and intact in the final pictures, to emphasize expression and gesture. After scanning these black-and-white drawings into Photoshop, she added color in the foreground and a strong, flat background color that changes on each spread in order to create a contrast in mood. Although she included vegetation and props to help show movement, she deliberately kept the spaces shallow, focusing on what mattered most: the way the animals interrelated.

"How Do You Make a Baby Smile? gave me a rare opportunity to use a contrast of styles—from the realism in the drawings of animals in their natural settings, to the flatter treatment for Baby's corresponding toy animals," she says. "The difference is clear from the title page, with its stylized toy crocodile. The 'real' croc that follows is more defined, but I used a similar color range so the contrast wasn't too abrupt."

Strevens-Marzo used a Pentel Brush pen for all of the animal drawings. "I like drawing directly from life with this brush, as it gets the adrenaline going—there is no chance to redo. Of all the animals I drew at the Paris zoo, the crocodile was the worst model because it didn't move. I overdid the drawing, as it gave me too much time. For another page, I had a block when it came to drawing crickets—Disney's Jiminy Cricket kept getting in the way. Then I found a great photo of a horde of baby crickets sitting on a stalk. They looked like young techno dancers with shaved heads. That set me going."

Using different Photoshop brushes and her stylus pen, Strevens-Marzo says she can feel the gloopiness of oil paint or a thin spread of watercolor as if she were using the real thing. For the crocodile, she used an eraser on overlays to reveal underlying colors as in scraperboard. "The computer enables me to try out different color schemes, but I refer to printed samples of process colors so I know how they will print out. The color in this book was exactly as I wanted."

Images © Bridget Strevens-Marzo.

Artist profile:

Steve Mack

Country of origin: Canada
Primary formats: Picture books, baby books, greeting cards, commercial illustration
Primary technique: Digital

Steve Mack grew up on Canada's Great Plains and has drawn for as long as he can remember. His first lessons in art were watching his grandfather do paint-by-numbers kits at their summer cottage. Later on in life, his mother would bring home used paper from her job as a data processor, and Mack would draw for hours on the unprinted side. He took every drawing class he could find at the local community center and spent every spare hour sharpening his drawing skills.

"My interest in what I wanted to illustrate changed as I grew up," he says. "At a very young age I was drawing my own children's books, and as I got a little bit older I wanted to be a cartoonist and did my own strips and gag panels. When I was a teenager, comic books were my main focus; then, as an art student at college, I began painting and learned how to use a computer, which lead me full circle back to children's illustration."

After graduating from a small design college as a self-confessed "visual communications know-it-all," Mack turned from graphic design back to his roots as an illustrator. He started freelancing in 2000 and has since had a steady climb upward. He has worked with major clients such as Target, Walgreens, Scholastic, Hallmark, Sterling Publishing, Harcourt, Chronicle Books, and also spent a year in Ohio working directly with American Greetings illustrating greeting cards.

1. "Whale in Stormy Seas,"
a personal work by Steve Mack.

Mack has now returned to Saskatchewan, Canada, and to full-time freelancing. He lives in a peaceful valley on a small farm with his wife and two small children. His books include *Steve Mack's ABC: An Illustrated Alphabet Compendium A Through Z, Jurassic Poop: What Dinosaurs (And Others) Left Behind* (written by Jacob Berkowitz), and *Hide-and-Seek: Dinosaurs!* (written by Betty Ann Schwartz). He is also a contributing author to *Cunning Lateral Thinking Puzzles* as well as the popular Illustration Friday blog (illustrationfriday.com).

2–4. Pages from *Steve Mack's ABC: An Illustrated Alphabet Compendium A Through Z.*

Creative process

Mack's working methods are similar from project to project. He works completely digitally using Illustrator and Photoshop as his main tools, though he prefers to use techniques based on 1950s and 1960s illustrators. "I love the ease of working digitally, but I do not want my illustrations to look like they have been computer-generated. I use a wide variety of textures in my work to give it a handcrafted feel."

"An art director will get in contact with me about the project," he says. "They will usually give me an outline on what they'd like to see, such as age group and if I should 'age up' or 'age down' my style. I'll then do 'sketches,' which I actually do in Illustrator, to give an indication of how things will look. If these are approved, I will then move on to finished illustrations. This will include color and lots of textures. If changes need to take place, it's very simple to move stuff around in Illustrator, since it's in vector format. I'll send the art director one last proof of the color and, if approved, I output my file in Photoshop or as a TIFF file and send it off via an FTP (file transfer protocol) site."

Mack's most recent book, *Hide-and-Seek: Dinosaurs!,* is an eight-page baby book with moving parts, illustrated in a bold, fun, and colorful style. Mack and the art director at Chronicle Books tried out a few different approaches before settling on the final look. "The art director wanted the dinosaur proportions to be very real. They also wanted cute, but not too cute! This was a bit of a juggle at first, but together I think we nailed it!"

5.

5. Holiday postcard for Painted Words Agency by Steve Mack.

6. Cover of *Hide-and-Seek: Dinosaurs!* written by Betty Ann Schwartz and illustrated by Steve Mack. All images © Steve Mack, except cover of *Hide-and-Seek: Dinosaurs!*, which is reprinted with permission from Chronicle Books.

Artist profile:

Carlyn Beccia

Country of origin: USA
Primary format: Picture books
Primary technique: Digital

Carlyn Beccia has been making art since she was young. She attended the University of Massachusetts Amherst and worked as a designer and animator in advertising before returning to her first true love: illustration. She is author and illustrator of *Who Put the B in the Ballyhoo?* and *The Raucous Royals*.

"Being a designer gave me strong composition and color skills," says Beccia. "It made me conscious of where the eye flows on a page. Animation taught me how to let a story unfold. I designed websites for a while, and I always treated them like big pop-up books, where a surprise should be on every page."

Beccia strives to make books that appeal to every age group. She also tries to tell a story off the page as much as on it. "Every book I write has a website to accompany it, giving readers additional information. All of my books have a very interactive experience where the reader is asked to participate in the story. Especially with *The Raucous Royals*, I invite the reader to unravel the mystery. I have always seen history as a changing landscape and not one static viewpoint—too many history books do not allow the reader to question the information. I am always giving a little wink to the reader and asking them to share in the secret."

Factual accuracy is very important to Beccia, and she spends a lot of time researching costumes. "The National Portrait Gallery and the British Library [London] were a huge help," she says.

1.

1–4. Self-promotional art by Carlyn Beccia.

3.

Jack Black
THE RAT CATCHER

2.

"Because we don't always know for certain what famous historical people looked like, the costumes can often be the vital key to identify who the person was. I rely on my imagination for facial expressions, compositions, and main action, but the details are always based on careful research."

For her picture books, Beccia uses Corel Painter almost exclusively, with some Photoshop adjustments. She uses the Real Round brush on a wood grain paper and sets the Feature high enough to retain the bristle marks. She also uses the Oils detail brush for smaller places and the Thick Wet Camel for deeper impasto effects (also found under the Oils brush category).

"I work this way because I found it closely mimics my traditional oil paintings. The benefits are no noxious fumes or mess, and multiple undo functions. The challenge is that people still tend to look at digital art as computer-generated art. I hate that term. It makes it sound like the computer generated the art. My hand generated the art. When people ask me what medium I use, I always say 'digital oils.'"

Beccia is currently finishing her third book, tentatively titled *I Feel Better with a Frog in My Throat.* "This book illustrates the wackiest medical cures used throughout history—leeches, bat dung, unicorn horns," she says. "I am currently practicing how to make blood stains using all of Painter's drippy brushes!"

A crow sat on a willow tree,
Eating her tiffin of brie,
The fox below grinned up at her,
"Pretty crow, please sing to me.

"I never saw such grace,
As the curve of your jaw,
But is your regal bill,
As lovely as your caw?"

Crow puffed out her chest,
And arched her feathered back,
Opened her mouth to sing,

And lost
her
tasty
snack.

4.

Workthrough: Corel Painter

In this tutorial, Carlyn Beccia demonstrates how she created a medieval witch standing guard over her cats. No reference photo was used.

1. Initial sketch
I first drew a pencil sketch and then scanned it into my computer.

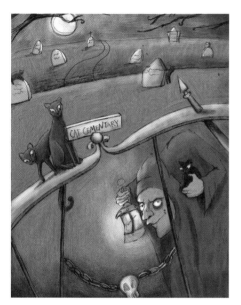

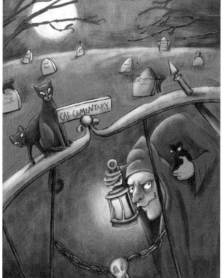

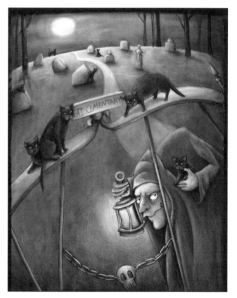

2. Base colors
I opened the scanned image in Corel Painter and, using blue as a base, fleshed out the colors with the RealBristle Oil brushes. I chose Curled Wood Shavings as the paper to give a slight texture to the surface.

3. Texture added
I increased the Feature (found under the Brush controls) of the Real Round Oil Brush so that the brushstrokes showed through (the image has now started to look more like an oil painting).

4. Composition adjusted
At this point, I decided that the trees were competing with the witch and needed to recede more into the distance. To accomplish depth of field, I chose to show only the base of the trees instead of the more intricate branches. With the Oils Glazing Round 30 Brush, I then added a wash of blue to the trees to give an atmospheric perspective (blue helps images recede). I also added a third cat in the foreground to balance the composition.

6. Frizzy Brushes... not just for hair

You can use a custom frizzy brush to give your paintings a random, grainy texture. For example, I increased both the Feature and the Random setting of the custom brush to give the night sky some erratic fog.

To create a custom frizzy hair brush using the Brush Creator, select the Real Round RealBristle Brush as a base brush. Go to Window>Show Brush Creator. In the Brush Creator, set the size of the brush to around 20 and the Minimum Size to 28%. Set the Feature to around 7.0—a higher setting will spread the hairs out more, and a lower setting will clump the hairs together and give you smoother hair. Set Random to something higher than 1.5 to give a jagged appearance.

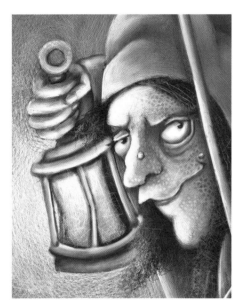

5. A new hairdo for the witch

I felt the witch needed some hair to glam her up a bit, so I created her frizzy hair by making a custom brush using Painter's Brush Creator.

Tip

Once you have the brush that gives you just the right amount of kinky wildness, save it for a later use. You can do this by selecting "Save Variant" where your brush is located. Name it something useful like "Frizz" so that you will remember what it looks like.

Artist profile:

Bob Staake

Country of origin: USA
Primary formats: Picture books, graphic novels, wide range of media
Primary technique: Digital

Picture books are an essential part of Bob Staake's voluminous and eclectic design and illustration output. His images appear on everything from magazines to books, animation to greeting cards, advertising to newspapers, and cereal boxes to CD-ROM games. Staake's November 17, 2008 cover of *The New Yorker*, entitled *Reflection*, commemorating Barack Obama's presidential election win, led the *TIME* list of "10 Top Magazine Covers of 2008."

Staake has authored and/or illustrated more than 40 books for children and adults, including *The Complete Book of Caricature*, *The Complete Book of Humorous Art* (both authored by Staake), and a Grant Wood-inspired graphic novel set in 1935, *The Orb of Chatham. The New York Times* named his picture book *The Red Lemon* as one of the 10 best illustrated books of 2006. One of his most recent picture books is *The Donut Chef*, a rhyming tale about dueling bakers, pictured here. Staake lives and works in Chatham, Massachusetts, on the elbow of Cape Cod.

Painting with pixels

Staake takes a totally digital approach to all of his children's book work, and shares his technique in several online videos that can be found on YouTube.com (search with "Bob Staake"). Because of his fondness for flat shapes and simple geometry, many critics have suggested that Staake uses vector graphics software. Surprisingly, however, he still uses Photoshop 3.0 from 1995, a bitmap editor that helped him create his first digital picture book, *My Little ABC Book.* He especially enjoys using the splatter effect achieved with the Paintbrush tool.

"To get my head around the idea that this little pixel, this little square, is a block of color—that was enough for me," he says. "I start with a basic shape—a circle, a square, a splotch of color—I picture it in my mind, then I refine and refine until I find the right image."

Each picture book generally takes two to three weeks for Staake to complete—just two weeks in the case of *The Red Lemon*—and, intermixed with all of his other assignments and self-directed projects, he finishes three to four books each year. "I was never one to languish over an illustration. I make a decision, and I go with it. I'm not always right, but I'm right in that moment," he says.

1. Staake's studio space.

Poetic constraints

Nothing inspires Staake more than the challenge of creative limitations. "I like being forced to experiment," he says. "There's always a danger of repeating yourself, of staying too long in your comfort zone. With age comes a desire to do a little bit more."

Although he rarely varies his cartoony style and his "amoebic" approach to characters, Staake is always changing color palettes and exploring new avenues of storytelling. "Different parts of your personality emerge through different stories," he says. "I approach my books from the perspective that no five-year-old will ever buy a picture book—it's their parents or grandparents instead, so these books become an extension of the adult's taste. However, I also try to entertain myself, to engage my adult self and the former child in me."

To do this, Staake draws upon the heartbreaks and joys he felt as a child. "If you can include these elements, it brings a children's book to another dimension," he says. "The most noble picture books contain a universal truth that a child can take with them throughout their lives."

2. Cover from *The Donut Chef*.

On a more technical level, Staake believes there is a very definite symbiotic relationship between words and art. "Once you get to the point where you're leaning too heavily on one side, you're negating the importance of the other. If I can insert a concept, phrase, or word—what I call 'push words' or 'push concepts'— that will encourage a child to learn what that phrase, concept, or word means—I love doing that."

A pivotal event

On September 11, 2001, Staake was working in his Chatham studio on *My Little Golden Picture Dictionary* when the planes hit the World Trade Center in New York City.

Staake admits that he froze up, had to stop creating art for a short time, and even questioned the value of his work. It was the written reminders from his own readers that brought him back to his studio.

"When you get a letter from a child, or from a parent, that says, 'My kid never read at all until he/she discovered your book'— that's really powerful stuff. It compels you to go on, and to do an even better book the next time around."

3–5. Interior spreads from *The Donut Chef* by Bob Staake,© 2008 by Bob Staake. Used by permission of Golden Books, an imprint of Random House Children's Books, a division of Random House, Inc.

Staake believes in symbiosis between words and art.

5.

They made new flavors, quite bizarre,
Like Cherry-Frosted Lemon Bar,
And Peanut-Brickle Buttlemilk,
And Gooey Cocoa-Mocha Silk!

They tried new shapes beyond just rings --
Their donuts were such crazy things!
Some were square and some were starry,
Some looked just like calamari!
Some were airy, some were cone-y!
Some resembled macaroni!

Artist profile:

Meomi

Countries of origin: USA and Canada
Primary formats: Picture books, illustration, and design for multiple media
Primary technique: Digital

Vicki Wong (Vancouver, Canada) and Michael Murphy (Los Angeles, California) formed the artistic partnership known as Meomi in 2002. Their artwork and characters have since appeared on clothing, toys, and merchandise, and in magazines and books worldwide. Meomi has created art for clients including Google, Electronic Arts, Girls Inc., Hasbro, and Nick Jr., and also designed the Vancouver 2010 Winter Olympics and Paralympics mascots.

"Both Michael and I come from design school and studio backgrounds, though we dabbled in comics, illustration, and video in our personal time," says Wong. "I think Meomi is what happens when you meet someone who shares the same delusions as yourself. 'Let's run away together and live in a world of cute singing trees and happy dancing monsters.'"

Murphy adds, "When I think about it, Meomi really began from our mutual love of the picture book. I had seen one of Vicki's illustrations on her website, a cutaway drawing that reminded me of an illustration from *Barbapapa's Ark*, one of an amazing series of picture books by Annette Tison and Talus Taylor, first published in France in the 1970s. Sadly, I don't think the books were very established in the United States, and I only had the one book as a child. I contacted Vicki and was surprised to find out when she replied that she not only knew and loved the books but also had grown up watching the animated series! After my

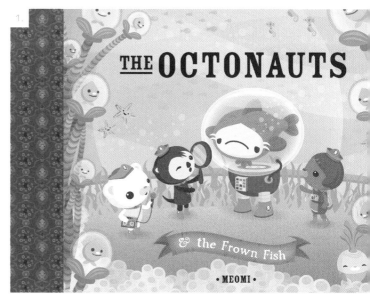

initial shock and jealousy, we continued to communicate through e-mail and realized that we were both passionate about critters and their stories."

Two other shared influences noted by Meomi are Tove Jansson's Moomin books and Richard Scarry's Busytown series.

1–4. Cover art and spreads from
The Octonauts & the Frown Fish.

These two artists collaborate primarily through the Internet.

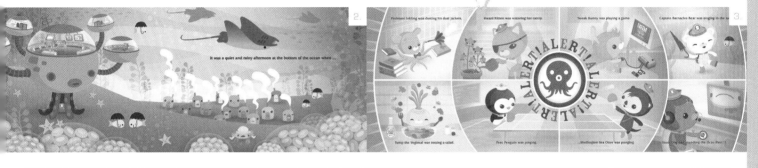

It was a quiet and rainy afternoon at the bottom of the ocean when ...

Professor Inkling was dusting his dust jackets.

Kwazii Kitten was watering her catnip.

Tweak Bunny was playing a game.

Captain Barnacles Bear was singing in the tub.

Tunip the Vegimal was tossing a salad.

Peso Penguin was pinging.

...Shellington Sea Otter was ponging.

Dashi Dog was expanding the Octo-Alert!!!

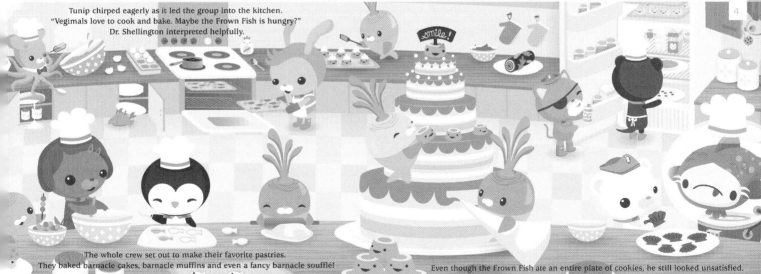

Tunip chirped eagerly as it led the group into the kitchen.
"Vegimals love to cook and bake. Maybe the Frown Fish is hungry?"
Dr. Shellington interpreted helpfully.

The whole crew set out to make their favorite pastries.
They baked barnacle cakes, barnacle muffins and even a fancy barnacle soufflé!

Even though the Frown Fish ate an entire plate of cookies, he still looked unsatisfied.

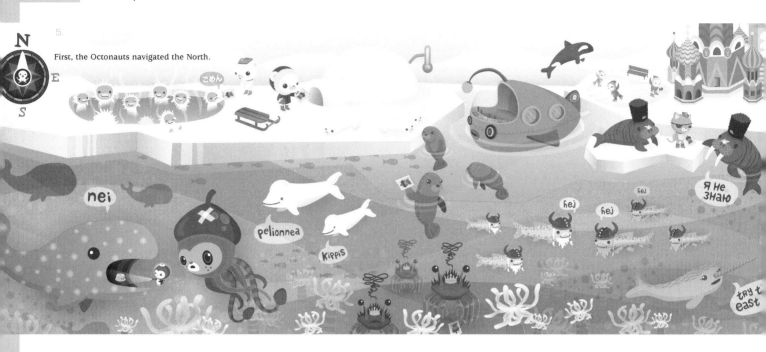

Digital collaboration

For Meomi, says Wong, "Everything is digital (created in Illustrator and Photoshop), so we just pass files back and forth over the Internet. We do everything together, writing and illustrating. We generally start with a concept and outline, which we flesh out into a script. We then do rough thumbnails of the spreads on paper and then jump onto the computer from there."

"Much like our collaboration on answering these questions," says Murphy, "it's a melee of instant messages, with calamitous disagreements but many serendipitous solutions! All of our favorite children's books were either written by the illustrator, or created by a collaborative team. It was shocking to me to find out that in the majority of picture-book publishing the story is written without any collaboration with the illustrator."

An artist's education

Wong attended the design program at York University in Toronto. "It was a good experience, namely because I had a cool teacher, Jimmy Peng, who was really into 'lateral thinking,' as he liked to term it. I think everyone develops differently; some people enjoy and flourish under schooling, and some people don't. Four years was just right for me."

Murphy says he is the kind of person who doesn't exactly flourish under formal schooling. "I initially flunked out of college. In my late twenties I went back to school at Washtenaw Community College—the only school I could get into with my grades! It was a much different experience. Within a semester, I went from not knowing how to double-click to being hired as the computer lab assistant, and I really appreciated the support I got from the teachers there." Murphy then transferred to the University of Michigan to undertake a degree in graphic design.

5. Spread from *The Octonauts & the Only Lonely Monster.*

6–7. Two spreads from *The Octonauts & the Sea of Shade.*

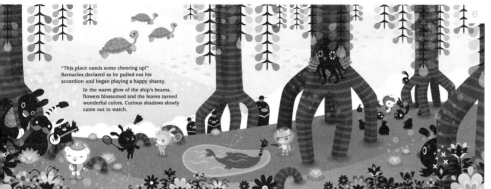

"This place needs some cheering up!"
Barnacles declared as he pulled out his
accordion and began playing a happy shanty.

In the warm glow of the ship's beams,
flowers blossomed and the leaves turned
wonderful colors. Curious shadows slowly
came out to watch.

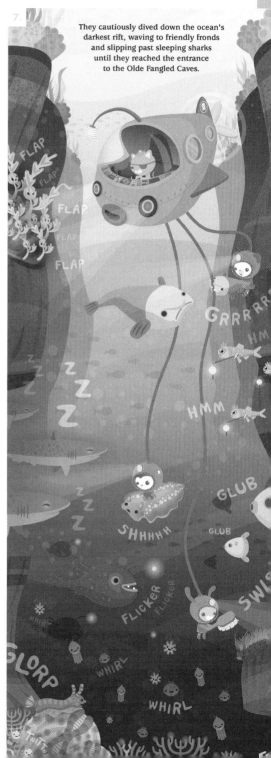

They cautiously dived down the ocean's
darkest rift, waving to friendly fronds
and slipping past sleeping sharks
until they reached the entrance
to the Olde Fangled Caves.

The Octonauts

The Octonauts are a crew of eight cute animals who live under the ocean in a giant ship called the Octopod. They enjoy going on adventures and exploring and experiencing the underwater world. The concept began as a series of online desktop calendars, for which Meomi would draw and post a new scenario of the Octonauts' world each month. There are currently three Octonauts books, all published by Immedium— *The Octonauts & the Only Lonely Monster*, *The Octonauts & the Sea of Shade*, and *The Octonauts & the Frown Fish*. "We've joked that an 'octology' of books seems fitting, but I don't think we need to stop there," says Murphy.

"Many things inspired this series," Wong says, "from my love for the ocean and our many aquarium visits, as well as BBC's *Blue Planet* series and Gerry Anderson's *Thunderbirds*. The books are a natural extension of this world, but in a more tangible format. Stories and worlds always come to me first as opposed to trying to create something for a specific medium or audience. Once the seedlings of the ideas sprout, they tend to develop in their own direction. Octonauts naturally lent itself well to children's books, though we find our actual audience to be very age-diverse. We would get booked to do storytime readings for infant and elementary school kids, but we'd also do signings at comic stores where we'd get enthusiastic adult attendees. I hope that our work defies age boundaries and can be appreciated by all ages on different levels."

Artist profile:

Jannie Ho

Country of origin: USA (born in Hong Kong)
Primary formats: Picture books, emergent reader books
Primary technique: Digital

Born in Hong Kong in 1976 and raised in Philadelphia, Jannie Ho (a.k.a. Chickengirl) moved to New York City to study illustration at Parsons School of Design. After working as a graphic designer at Nickelodeon and Scholastic, and as an associate art director at *TIME for Kids*, she decided that illustration was her true calling. She currently works and plays in New York City, where she creates humorous digital illustrations for the children's publishing industry.

Her recent children's book projects include a set of I'm Reading Now! emergent reader books published by Scholastic; *Halloween Howlers: Frightfully Funny Knock-Knock Jokes*, written by Michael Teitelbaum; *The Great Reindeer Rebellion*, written by Lisa Trumbauer; and *The Haunted Ghoul Bus*, also written by Trumbauer.

Ho's favorite children's book author is Richard Scarry. "His stories and illustrations make me want to live in his world, even now as an adult," she says. Most of her favorite illustration styles seem to come from France and Japan. Two French illustrators she loves are Marc Boutavant and Delphine Durand, and she recently discovered a popular Japanese children's book series called Bam & Kero by Yuka Shimada. She is also a fan of Japanese packaging design, manga, and anime. Other creative favorites include Mo Willems, Sara Varon, Mary Blair, and several vector artists such as J.otto Seibold, Chip Wass, Meomi, and Juliana Pedemonte of Colorblok.

1.

1. Ho's studio space.

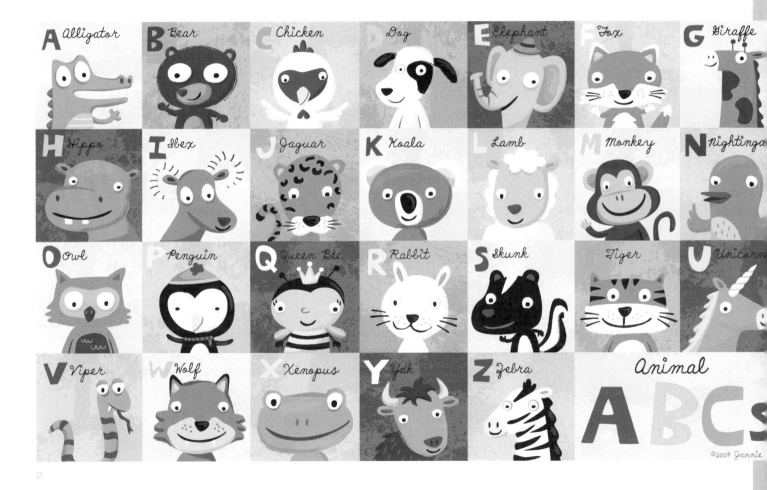

2.

2. Self-promotional work © 2009
by Jannie Ho.

Illustrators provide a "second story" to a manuscript...

Working digitally

Ho's first job out of college in 1999 required her to learn Illustrator inside and out. She was still doing a lot of traditional painting with gouache but found it easier to express her ideas and bring them to fruition using digital tools. "Plus," she says, "I wasn't quite comfortable with my painting skills. Working in vectors was especially appealing because of the look and also the ease of editing. I can move things around and experiment with colors quite easily in a way I can't with traditional media. However, I try to give my work an organic and handcrafted feel whenever possible, avoiding the cold, mechanical quality that can be present in digital work. Sometimes people aren't sure if my work is done digitally!"

Most of Ho's projects begin with a sketch drawn by hand on paper, which she then scans. Using Illustrator, she builds the different shapes over the sketch, separating each element on its own layer. After blocking out the simple shapes, mostly using the Pen tool, she draws in the details and applies shadows and textures, using the Brush palette or placing textured TIFF files from Photoshop. She then groups the objects together, which gives her the ability to try out different compositions.

"The division between traditional and digital art is slowly fading," she says. "But as a digital artist I can still see mixed feelings in the industry. I've had experiences where art directors simply

won't look at my work because it's digital—they've dismissed it right away without even viewing it. And then I have art directors who fully embrace it. From a creator's perspective, I believe it's the best medium. I can manipulate it and play around with colors and perspectives over and over to my heart's content. There is beautiful work out there that is created digitally from the first sketch to the final art."

Jannie Ho on visual storytelling

Establishing all the characters' physical features and personalities is important, as is remaining consistent throughout the pages of the book. I love it when a character's personality develops as I'm working on a book—the more time I spend with a character the more it shows in my art. Illustrators not only illustrate what is in the text but also what is not in the text, providing a "second story" to the manuscript. My main concern is to blend text and imagery together to make a unified story. I also love adding little details that children will be able to find; it's almost like a shared secret between myself and the reader.

3–6. Self-promotional work, © 2009 by Jannie Ho.

Expert commentary:
Jean Gralley

Jean Gralley is an American picture-book writer and illustrator who publishes with Henry Holt Books for Young Readers. She studied with Maurice Sendak at Parsons School of Design in New York City, and has written about digital picture books in The Horn Book *and* CBC Features, *among other publications. Her animation* Books Unbound *has been shown in museums to demonstrate "the future of the picture book." In addition to print, Gralley also makes digital picture books, which move and are advanced forward and backward by the reader. All of her digital picture books, so far, also have musical soundtracks. She has plans to start a company, Go Books, to produce these new digital books. Here she shares her essay "Brave New Picture Books," which was first published in 2008 in* Sprouts, *a publication of the Society of Children's Book Writers & Illustrators, New Jersey (reprinted here with kind permission).*

1–2. Stills from *Books Unbound* animation. © 2006 Jean Gralley.

Brave New Picture Books

I have a lot to say about digital picture books. All of it can be boiled down to three things. The first two: (1) Most digital picture books today are direct transfers from paper to screen; and (2) This is too bad.

Paper picture books on the screen can be seen on more and more websites, some with page turns that seem almost realistic. Because they're novel, almost-realistic page turns have a certain "wow" factor but let's face it: these books go a long way just to do what paper does. That, to my thinking, is what's too bad. When it comes to replicating paper, paper will always do it better.

Undoubtedly, we put paper books on screen because that's what we've decided a picture book is: words and pictures on 32 pages of paper. But now that we have books in digital environments, things that were once conventional can be questioned. Without the requirements of printing and signatures, must a digital book have any specific number of pages? Does it have to remain static? Must it move left to right only? And what's a "page," anyway?

I've liked thinking about these kinds of questions for a long time. The conventions of books, I've realized, are less about books and more about *paper*. Can we dare to separate them?

This brings us, finally, to the third point: (3) When we separate "books" from "paper" we're freed to take the tremendous opportunity digital gives us to create a new kind of picture book. When we let digital be digital, we can engage even reluctant readers with the written word in exciting new ways.

This is something best shown rather than described. In 2005 I created a short Adobe Flash movie called *Books Unbound*. It attempts to demonstrate what a book not based on a paper model might look like.

Books Unbound has been shown in the Katoneh Museum in Katoneh, New York, The Eric Carle Museum of Picture Book Art in Amherst, Massachusetts, and traveled across the United States to Los Angeles. It can also be viewed on my website. I invite you to take a look (jeangralley.com/books_unbound).

After viewing *Books Unbound*, you may ask if something with words and pictures that move and morph can ever be called a book. It's a good question. The question can also be a polite way to wonder if it can be dis-invited to the "club," our well-defined world of books, book writing, and illustrating. I think it'd be wrong to not welcome it in.

I could be sentimental here, but I'd like to believe books are elastic by definition. Isn't a scroll a kind of book? Wasn't Trajan's Column perhaps an early comic book? I like to think so. I want to believe the book form endures because it's alive, responsive to its times and the materials of its times. Digital could be one more incarnation in a long line of book forms.

I also think choosing to include digital in the family of books can be more serious than sentimental. We publishers and book creators are the gatekeepers of quality literature for children. Our choice has consequences. As children turn more and more frequently to digital for reading that interests them, can we dither about whether to embrace it enthusiastically, reluctantly, or not at all? We should embrace it with absolute enthusiasm. It is a creative, amazing medium with potential for excellence.

But the last and perhaps best reason of all to embrace digital is that it is fun. Everywhere I present even my simple examples of the possibilities to writers and illustrators, the response

3–4. Stills from "Skin n Bonz," a poem-in-motion. © 2009 Jean Gralley.

Digital can be a warm, pliant, imaginative medium.

is happiness. Digital can be a warm and pliant medium in the hands of imaginative picture-book creators. We could create ingenious, even heart-warming new stories, read and paced by our young readers. Knowing Flash is not required (although, like me, maybe you'd like to learn it). All that is required is the ability to imagine a story in motion.

While traditional, quality books for young readers continue to be created and published, I challenge our industry to build a parallel, digital universe of a new kind of book. Creative people are ready to break new ground; kids are ready to be excited. As an enthusiastic digivangelist, I'm ready to show more writers, illustrators, editors, and publishers the possibilities and get this big ball rolling.

We can create something that's innovative, creative, cool, and good. Meanwhile, our young readers are more than ready for the reading revolution. Let's run, not walk, to the revolution.

5.

5. Still from *The Full Treatment*, a picture book in motion explaining the processes of water treatment for young readers. Note the "advance arrow" on the right and the sidebar of chapters on the left. In this production, the viewer can click the sidebar to see any chapter in any order at any time. © 2008 Jean Gralley.

Multiple Markets

Liz Goulet Dubois on board books for babies and toddlers

An illustration graduate of Rhode Island School of Design, Liz Goulet Dubois writes and illustrates for the children's market, with an emphasis on books for very young children. Her many years as a product and toy designer have inspired a particular fondness for interactive books with novelty elements that children love. Clients include Scholastic, Houghton Mifflin, and Golden Books. She has written a pop-up book for toddlers titled What Kind of Rabbit Are You? *and is also a frequent contributing illustrator to* Highlights High Five *magazine. She lives and works from her home studio in Scituate, Rhode Island, which she shares with her husband and three book-loving daughters.*

Working on board books for very young children comes with some unique challenges. The text in this kind of book tends to be minimal, so the pictures are expected to convey a lot of the concept. The books need to be sturdy enough to withstand a baby or toddler's full attention, so they are usually printed on paper adhered to a thicker board. The thickness can vary, and this will sometimes change how your cover art wraps around the spine.

The artwork needs to be clear, with a minimal amount of clutter that detracts from the main concept. Any style of art can work in this format—popular art techniques found in board books now include cut paper, collage, paintings, and their many computer-generated versions.

1–3. Concepts such as dressing up and mealtimes are common themes in board books.

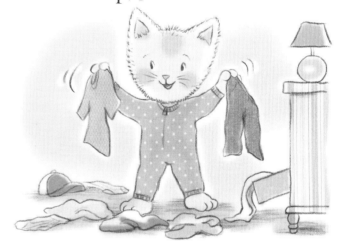

Dress up, playful Cuddlepuss!

Can you pick out your clothes?

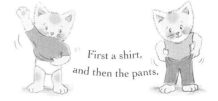

First a shirt, and then the pants,

then **kiss** that little nose!

Since many board books are too short to have a real plot or storyline (often having only 5–7 spreads or 10–14 pages), it's vital that the pictures contribute to the pacing of the book. Novelty elements such as flaps, pull tabs, pop-ups, or touch-and-feel panels, can be a great way to entice children to continue through a book.

When I work these kinds of features into a book I like them to be just as much of the story as the words. What's hidden behind that flap? What's coming next? Giving a child the "power" to make something happen all by themselves encourages a love of books. It makes turning the pages fun!

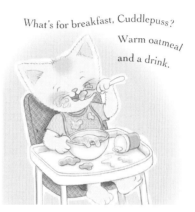

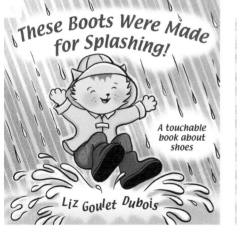

4–5. This cover concept and dummy book page show a place (the bottom of the cat's boots) designed to accept a touch-and-feel panel. The black area would be die-cut, and a soft, textured foam panel would be inserted to feel like a real boot bottom. All images © by Liz Goulet Dubois.

Illustrating books for older readers

From early readers and chapter books, to middle-grade and young adult (YA) novels, to nonfiction and biographies, illustrators for children have a wide range of options for working outside the picture-book form. Another growing option is the graphic novel, which we will discuss on pages 172–173.

The history of books for teen and preteen (tween) readers extends as far back as the nineteenth century, and is much too complex and multifaceted to encapsulate here (see pages 184–185 for Recommended Reading). Popular genres and subgenres for this demographic include fantasy and science fiction, horror, romance, and contemporary and historical drama, among others.

Illustrations in books for older readers are often secondary to the text; however, even in text-driven books, authors and artists are inventing new ways to integrate words and images. Nonetheless, just as for picture books for young audiences, illustrating for older readers is an art of careful selection, choosing the precise moments that should be visualized.

As writer-artist Mary Jane Begin says of illustrating a new version of Kenneth Grahame's *The Wind in the Willows*, "It's a longer text, and there's so much there to choose from as an illustrator. You have to actually edit the number of scenes you could draw. There's more room for vision to land as opposed to the shorter texts."

Pen-and-ink spot art and vignettes are still prevalent in chapter books and middle-grade fiction, and full color is generally reserved for cover art, which is, in itself, a lucrative specialty for many artists, especially in the YA field.

1–5. Cover and interior illustrations from book one of the Ghost Girls series, *The Haunting on Devil's Den Road* by Karen Chilton, illustrated by Gary McCluskey (ghostgirlsbooks.com).

Images © Karen Chilton
and Gary McCluskey.

Comics for kids

Whether you call them comic books, manga, graphic novels, or *bande dessinée*, comics are surely the close cousins of picture books. Many artists and critics have even argued that the two are variations on a single form: what legendary cartoonist Will Eisner labeled "sequential art."

Some of the most celebrated picture-book authors, including Maurice Sendak (*In the Night Kitchen*) and Raymond Briggs (*The Snowman*) to name just a couple, have succeeded in integrating the unique visual vocabulary of comic strips and cartoons into their picture books. The "grammar" of comics encompasses speech and thought balloons, framed panels showing continuous narrative across a page (often with an empty space called a "gutter" between panels), action lines, and stylized sound effects, among other techniques.

Over the past 80 years, Belgium and France have provided the world with enduring models for comics in book format with the graphic albums featuring Hergé's *The Adventures of Tintin* and René Goscinny and Albert Uderzo's *The Adventures of Asterix*. American comic books have provided a parallel model of dynamic panel-to-panel storytelling that gave rise to both the superhero and, arguably, the contemporary graphic novel.

Equally influential, if not even more so among the youngest generation of picture-book illustrators, has been the global hyper-explosion of Japanese manga and anime. When master storyteller Osamu Tezuka created his *New Treasure Island* at the end of World War II, he did not predict the multibillion-dollar manga market (bolstered by films and related products) that still exists and continues to grow worldwide.

1–2. Two online strips from *Sticky Burr* by John Lechner. © John Lechner.

3–4. Two pages from *The Dreamland Chronicles*, an all-ages three-dimensional comics series self-published online and in print by Scott Christian Sava. © Scott Christian Sava.

Liz Goulet Dubois on other markets

Illustrating for children's magazines is an excellent way of supplementing your children's book work. Freelance magazine work tends to be faster-paced, and with shorter deadlines. The quantity of work needed for a bimonthly or monthly magazine means that work is continuously being assigned. The artwork in children's magazines can vary from loose, trade-book style to tight, accurate educational-style art. Any kind of art can be used in magazines, but sometimes digital art is preferred because of the ease of making corrections and the ability to insert the art into a layout quickly.

Clarity is a big issue in children's magazines. Whether you are illustrating a story, a game, or a craft, it's important that children can understand your pictures. The art must work with and support the text. Being a relatively fast, efficient artist is a plus. Overall reliability is a top concern to magazine editors and art directors. Your ability to supply the necessary artwork and respond quickly to corrections and any needed changes makes you an asset to the in-house staff. Payment for magazine work varies from publisher to publisher. Some pay upon delivery of the art, while others pay on publication, which can be many months from when you finish the art. Find out exactly how your publisher works up front so that you aren't surprised later.

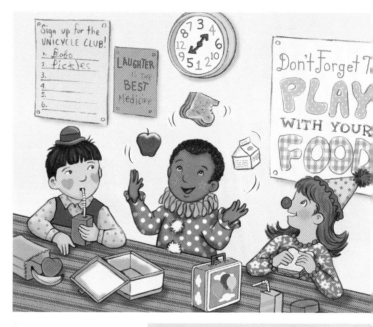

1–2. Art intended for use in children's magazines often depicts children interacting with each other. It's important to make sure that all kinds of children are shown. © Liz Goulet Dubois.

Creating art for children's products and packaging

Books and magazines are not the only places to find children's art. Check out greeting-card racks, or the cotton and flannel prints available at fabric stores. Many industries and companies use child-friendly art for their products. Toy and gift stores are great places to find out which companies are using your style of art, and what kinds of products they are using them for. Be a trend-watcher, not only for trends in art but also in terms of what kinds of items seem to sell well.

Child-friendly products such as toys, tableware, bedding, clothing, and accessories often begin with artist renderings. Artwork of this kind can be commissioned by a manufacturer for a particular product, or created by you, the artist, to be sold through a licensing agreement. Licensing your artwork gives a company the permission to use your art for specific purposes, the details of which should be spelled out in a contract. Licensors can pay you outright for your work or, more likely, will pay you royalties against the sales of whatever item is created. These kinds of agreements can be complicated, but are well worth investigating if you like the idea of seeing your product on store shelves. Pursuing other kinds of artwork opportunities like these can be a great way to fill in the gaps between commissioned book work.

3. This art was digitally created. It can be applied to any number of products including stationery, gift wrap, fabric, and party goods, © Liz Goulet Dubois.

4–5. Orthographic drawings are used to explain how a product should look. Barring any technical difficulties, the final product should closely resemble the drawings. © FRED. Design by Liz Goulet Dubois.

Expert commentary:
Judy O'Malley

We asked veteran editor Judy O'Malley (see pages 36–37) to provide advice for illustrators entering the children's book field. Here she discusses agents and artists' representatives, networking, self-representation, education, and research, among other topics. While O'Malley's insights are most directly applicable to illustrators living and/or publishing work in North America, we believe her suggestions are also valuable for international illustrators as well. See the Additional Resources section for further useful information.

Before considering the need for an agent, an emerging writer or artist must develop their craft. In addition to learning the mechanics of those arts, it's imperative to study classic and contemporary picture books. Reading widely in the genre, as well as consulting professional works on children's books, establishes a foundation upon which the writer or illustrator can begin to build a personal style. Becoming involved with international organizations like the SCBWI, reading children's literature journals, and following children's book Listservs and blogs are all excellent ways to become informed about the business, as well as the craft, of writing and illustrating for young readers. Attending local children's literature conferences and workshops presents opportunities to meet editors and art directors and to gain access to critiques and portfolio reviews.

Although some publishers have closed their doors to unagented work, many do accept unsolicited manuscripts and illustration samples, and guidelines for submission are usually posted on the publisher's website. Whether an author or illustrator needs and/or wants an agent depends on how comfortable that artist is with the business side of publishing. Making good contacts with editors is important in self-representation, as is being willing to take the time away from other work to prepare, send, and track submissions. Also key is the ability to negotiate terms and deal with complex contracts.

1–3. Character art by Elizabeth Matthews.

If working with an agent seems like an expedient option, it's important to do thorough research and vet any agent before signing an agreement. Reputable agents do not charge "reader's fees" or ask for any type of payment from a writer or artist. Because they receive a commission from the sales of the book, competent agents will only take on projects that they believe are both publishable and marketable. Like publishers, experienced agents and artists' representatives are overwhelmed with submissions. SCBWI's *Publications Guide* (a valuable perk for members of the organization) provides helpful advice on choosing an agent who can best fit your needs in promoting and marketing your work.

As with editors and art directors, agents and artists' representatives are often asked to speak at conferences sponsored by local chapters of SCBWI and other groups. Attending such events is an excellent way to get a sense of the agent's style and preferences, and after the workshop or conference, agents will often accept submissions from attendees for a limited time. Whether or not a writer or artist decides to seek representation, it is extremely important to be proactive in assessing various resources, avenues, and options for getting published.

Images © Elizabeth Matthews.

Expert commentary:
Tessa Strickland

Tessa Strickland is the cofounder and editor in chief of Barefoot Books, which has offices in the UK and the US. The second of five children, she was brought up in rural Yorkshire, UK, and spent most of her childhood surrounded by farm animals. After a long illness as a teenager, her interest swung from ponies to books, and she became fascinated with the beliefs and values of different cultures. She now divides her time between caring for her three children and running Barefoot Books, which she regards as her fourth, and most demanding, child.

How do you define a "picture book"?

To me, a picture book is a book that tells its story through pictures as well as words, and one in which the pictures are in a close relationship with the words, yet also tell the story in their own way. The balance of illustration to text may vary, but there will likely be illustrations on every double-page spread.

What is your current role at Barefoot Books, and how do you coordinate your work between the UK and US offices?

I cofounded Barefoot Books with Nancy Traversy, my business partner, back in 1993. As the company's editor in chief, I focus on sourcing and developing the books and related audio and gift products. In this capacity, I work across the business—whatever we develop, we develop for the world market and publish in both the UK and US. I also oversee the running of the UK office and our international foreign rights business.

What are some of the essential qualities you look for in a successful picture-book submission, both in terms of writing and art? Also, what qualities do you look for in an artist's portfolio?

With both writing and art, I look for work that has its own voice and that has resonance and beauty. It may be humorous, or it may be serious, but I want it to be distinctive. I want to read the author's manuscript or to look at the artist's portfolio and feel the characters tugging at my coat. When this happens, I know something interesting is afoot and I will work as best I can to bring the project to life. Sometimes this happens very easily—I read a story and know straight away who I want to illustrate it. But sometimes it can take much longer—it took four years to find the right artist for *The Boy Who Grew Flowers* (written by Jen Wojtowicz and illustrated by Steve Adams, see pages 56–57).

After more than 15 years in publishing, what are a few of the major ways that you have seen children's books change, and how has Barefoot Books responded to those changes?

You can't begin to talk about publishing without acknowledging the social and cultural revolution that is the Internet. For us, as for many small businesses, the Internet presents an opportunity—it gives us a way to get directly to our audience, which we define as children everywhere, and the parents and teachers who are responsible for them. The Internet gives us an opportunity to get past the domination of the book chains and supermarkets, whose selections often appear to me, as a parent, to be driven by short-term gain for the shareholders rather than long-term value for the customers. At its best, the Internet is a powerful vehicle for democracy and diversity, and this is why we continue to invest in our own website and in building a Barefoot community.

What are some of the key differences between the UK and US markets for children's books today, in your experience?

I don't really see myself as developing books for the UK and the US; what I notice is that the books attract people with a certain kind of sensibility, and those people can be anywhere in the world. That said, the most obvious difference between the UK and US markets is that hardcover editions fare far better in the US than in the UK. Also, children's picture books are taken more seriously as small masterpieces and works of art in their own right in the US, though this is changing, partly as a result of the Big Picture campaign run in the UK by the charity Booktrust. Other than that, there are far more similarities than differences and, with very few exceptions, the same books tend to do well in both markets.

What additional advice would you give to an aspiring picture-book writer or illustrator?

Go beyond family and friends for feedback; children are your audience and their responses can be the most valuable. If you are writing, you'll soon find that reading your work aloud to a young focus group gives you a lot of insight into what is and isn't working. If you're illustrating, remember that the cornerstone of illustration is good draftsmanship. It is not as well or as widely taught as it used to be, but it makes all the difference between a good book and a fantastic one. Also, devote yourself to finding your own voice. Use rejections to find out what publishers are looking for, but don't take them personally. And last of all, practice and enjoy practicing—it shows!

Additional Resources

Afterword:
Dr. Kenneth and Sylvia Marantz

Dr. Kenneth Marantz and Sylvia Marantz have been involved with children's books, art education, and libraries for more than 50 years. Together, they have written several books, including The Art of Children's Picture Books: A Selective Reference Guide; Artists of the Page: Interviews with Children's Book Illustrators; Creating Picturebooks: Interviews with Editors, Art Directors, Reviewers, Booksellers, Professors, Librarians and Showcasers; *and* Multicultural Picturebooks: Art for Illuminating Our World. *Sylvia is now a retired school librarian, and Kenneth is Professor Emeritus at Ohio State University. They both have honorary professorships in visual communications at the Columbus College of Art and Design and adjunct appointments at Kent State University. They have long been prominent critics and reviewers, and Kenneth has twice served on Caldecott Medal committees. In 2008 their extensive and carefully shaped collection of picture books was moved to the Kent State University Library and named the Marantz Picturebook Collection. Here they provide a brief but wide-ranging assessment of several crucial aspects of the picture-book field and form. (Please note the Marantz's use the term "picturebook" as a single word to distinguish it from related forms such as comics and illustrated novels.)*

Definitions of complex organisms like picturebooks are, at best, approximations. They have roots in two expressive families: pictures and words. They combine in an effort to tell a story. Most often they are parallel in design, with each bearing a responsibility not necessarily of equal weight, although on somewhat rare occasions the story is shaped without words.

A major problem is to determine how many words are too many: when does the picturebook become an illustrated book, that is, a book with some illustrations? One "test" might be to see if the story can be understood when one eliminates the words. Indeed, there are many picturebooks where the words seem redundant, where they provide little in the way of information or emotional content. But in most cases, in order to be called a picturebook, both text and visual content should play significant roles.

Although we value picturebooks as art objects, we realize that they are also commodities. In recent years, as "business" has become more dominant, editorial concerns and the field itself have suffered. Sales are the driving force, and the marketing part of publishing houses command too much influence on the what and how of book production. Typical of the situation is the emergence of celebrity authors whose names make the sales.

Photograph by Gary Harwood, Kent State University.

Nevertheless, probably helped by an increase in the number of international artist/authors being published in the US and |the start-up of several new independent smaller presses, there are still a sizable number of fine, imaginative picturebooks published each year. The industry is adding to the bulk of books for the very young as well as novelty books that focus on gimmicks like flaps and penetrations rather than stories.

We remain concerned about the disappearance of independent bookstores with knowledgeable staffs as the large chains and supermarkets have eyes only for profits. From our contacts with publishers, artists, and authors, however, we are still certain of the serious efforts they make to create many worthwhile picturebooks.

We value picturebooks for their craftsmanship, creative design, emotional content, and innovative technology. Books produced in previous periods look different because print technology has evolved, but we still enjoy reading them. And there is still the thrill of surprise and discovery when a book arrives by a promising new artist, or by a familiar friend who has produced another gem.

We also enjoy attending conventions to visit with publishers and artists, to handle the new picturebooks, and decide which we want to review. There's a sense of community that permeates the interactions at conventions and which remains vital; one that adds to the sense of significance in the creation of these books.

Finally, it takes a few readings of autobiographical materials by picturebook authors and artists to appreciate the variety of paths that they have followed. What those who have achieved stature in the field have engaged in is an education that includes skill development. Many have roots in traditional art or literature programs and continue to exhibit or publish in other fields. Very few can make a living just from picturebooks. Many mature as they produce picturebooks, a form of self-education no doubt aided by sensitive editors.

But the only activity we would suggest for budding picturebook makers is to become familiar with the genre from post-World War II to today. The field is now increasingly global, so an effort should be made to investigate the international works. Aside from technical skills, successful books demand imagination, and fresh ways to interpret existing stories as more original storylines.

Recommended reading

A Caldecott Celebration: Seven Artists and Their Paths to the Caldecott Medal by Leonard S. Marcus (Walker & Company, 2008)

A Caldecott Celebration: Six Artists and Their Paths to the Caldecott Medal by Leonard S. Marcus (Walker & Company, 1998)

A Picture Book Primer: Understanding and Using Picture Books by Denise I. Matulka (Libraries Unlimited, 2008)

Aesthetic Approaches to Children's Literature: An Introduction by Maria Nikolajeva (Scarecrow Press, 2005)

American Picturebooks from Noah's Ark to The Beast Within by Barbara Bader (Macmillan, 1976)

An Introduction to Art Techniques by Ray Smith, Michael Wright, and James Horton (Dorling Kindersley, 1996)

Artists of the Page: Interviews with Children's Book Illustrators by Sylvia Marantz and Kenneth Marantz (McFarland, 1992)

The Art of Maurice Sendak by Selma G. Lanes (Abrams, 1980)

The Art of Maurice Sendak: 1980 to the Present by Tony Kushner (Abrams, 2004)

Artist to Artist: 23 Major Illustrators Talk to Children About Their Art by the Eric Carle Museum of Picture Book Art (Philomel Books, 2007)

Author Talk: Conversations with Judy Blume et al., compiled and edited by Leonard S. Marcus (Simon & Schuster Books for Young Readers, 2000)

Bemelmans: The Life and Art of Madeline's Creator by John Bemelmans Marciano (Viking, 1999)

Bill Peet: An Autobiography by Bill Peet (Houghton Mifflin, 1989)

Caldecott & Co.: Notes on Books & Pictures by Maurice Sendak (Farrar, Straus, and Giroux, 1988)

Character Design for Graphic Novels by Steven Withrow and Alexander Danner (RotoVision, 2007)

Children's Book Illustration: Step by Step Techniques: A Unique Guide from the Masters by Jill Bossert (RotoVision, 1998)

Children's Books and Their Creators, edited by Anita Silvey (Houghton Mifflin, 1995)

Children's Literature: An Illustrated History, edited by Peter Hunt (Oxford University Press, 1995)

Children's Literature: A Reader's History, from Aesop to Harry Potter by Seth Lerer (University of Chicago Press, 2008)

Children's Writer's and Illustrator's Market (Writer's Digest Books, annual)

The Complete Idiot's Guide to Publishing Children's Books (Third Edition) by Harold D. Underdown (Alpha Books, 2008)

Creating Picturebooks: Interviews with Editors, Art Directors, Reviewers, Booksellers, Professors, Librarians and Showcasers by Kenneth A. Marantz and Sylvia S. Marantz (McFarland, 1998)

Dear Genius: The Letters of Ursula Nordstrom, collected and edited by Leonard S. Marcus (HarperCollins, 1998)

Design Basics by David A. Lauer and Stephen Pentak (Wadsworth Publishing, 2008)

Drawing for the Artistically Undiscovered by Quentin Blake and John Cassidy (Klutz Press, 1999)

Drawing with Color by Judy Martin (Studio Vista, 1989)

Drawing Words and Writing Pictures: Making Comics, Manga, Graphic Novels, and Beyond by Jessica Abel and Matt Madden (First Second Books, 2008)

Dreams and Wishes: Essays on Writing for Children by Susan Cooper (Margaret K. McElderry Books, 1996)

The Encyclopedia of Drawing Techniques by Hazel Harrison (Running Press, 2004)

Encyclopedia of Writing and Illustrating Children's Books by Desdemona McCannon, Sue Thornton, and Yadzia Williams (Running Press, 2008)

Essential Guide to Children's Books and Their Creators, edited by Anita Silvey (Houghton Mifflin, 2002)

From Mother Goose to Dr. Seuss: Children's Book Covers, 1860–1960 by Harold Darling (Chronicle Books, 1999)

Funny Business: Conversations with Writers of Comedy, edited by Leonard S. Marcus (Candlewick Press, 2009)

Golden Legacy: How Golden Books Won Children's Hearts, Changed Publishing Forever, and Became an American Icon Along the Way by Leonard S. Marcus (Golden Books, 2007)

Graphic Storytelling and Visual Narrative by Will Eisner (W.W. Norton, 2008)

The Hidden Adult: Defining Children's Literature by Perry Nodelman (Johns Hopkins University Press, 2008)

How Picturebooks Work by Maria Nikolajeva and Carole Scott (Routledge, 2006)

Illustrating Children's Books: Creating Pictures for Publication by Martin Salisbury (Barron's Educational Series, 2004)

Inside Picture Books by Ellen Handler Spitz (Yale University Press, 1999)

It's a Bunny-Eat-Bunny World: A Writer's Guide to Surviving and Thriving in Today's Competitive Children's Book Market by Olga Litowinsky (Walker & Company, 2001)

Licensing Art 101: Publishing and Licensing Your Artwork for Profit by Michael Woodward (ArtNetwork, 2007)

Making Comics: Storytelling Secrets of Comics, Manga and Graphic Novels by Scott McCloud (HarperCollins, 2006)

The Making of Goodnight Moon: A 50th Anniversary Retrospective by Leonard S. Marcus (HarperTrophy, 1997)

Margaret Wise Brown: Awakened by the Moon by Leonard S. Marcus (Beacon Press, 1992)

Minders of Make-Believe: Idealists, Entrepreneurs, and the Shaping of American Children's Literature by Leonard S. Marcus (Houghton Mifflin, 2008)

Multicultural Literature for Children and Young Adults: Reflections on Critical Issues by Mingshui Cai (Greenwood, 2002)

Multicultural Picturebooks: Art for Illuminating Our World by Sylvia and Ken Marantz (Scarecrow Press, 2005)

Pass It Down: Five Picture Book Families Make Their Mark by Leonard S. Marcus (Walker & Company, 2006)

Picture This: How Pictures Work by Molly Bang (Chronicle Books, 2000)

Play Pen: New Children's Book Illustration by Martin Salisbury (Laurence King, 2007)

Pleasures of Children's Literature by Perry Nodelman and Mavis Reimer (Allyn & Bacon, 2002)

The Potential of Picturebooks by Barbara Kiefer (Prentice Hall, 1994)

75 Years of Children's Book Week Posters: Celebrating Great Illustrators of American Children's Books by Leonard S. Marcus (Alfred A. Knopf, 1994)

Show & Tell: Exploring the Fine Art of Children's Book Illustration by Dilys Evans (Chronicle Books, 2008)

Side by Side: Five Favorite Picture-Book Teams Go to Work by Leonard S. Marcus (Walker & Company, 2001)

Storied City: A Children's Book Walking-Tour Guide to New York City by Leonard S. Marcus (Dutton Children's Books, 2003)

Talking with Artists, Volumes One through Three by Pat Cummings (Clarion Books, 1992-1999)

Through the Looking Glass: Further Adventures & Misadventures in the Realm of Children's Literature by Selma G. Lanes (David R. Godine, 2004)

Under the Spell of the Moon: Art for Children from the World's Great Illustrators, edited by Patricia Aldana (Groundwood Books, 2004)

Understanding Comics: The Invisible Art by Scott McCloud (HarperCollins, 1994)

Vector Graphics and Illustration: A Master Class in Digital Image-Making by Jack Harris and Steven Withrow (RotoVision, 2008)

The Wand in the Word: Conversations with Writers of Fantasy, compiled and edited by Leonard S. Marcus (Candlewick Press, 2006)

Ways of Telling: Conversations on the Art of the Picture Book by Leonard S. Marcus (Dutton Children's Books, 2002)

Ways of the Illustrator: Visual Communication in Children's Literature by Joseph H. Schwarcz (American Library Association, 1982)

Words About Pictures: The Narrative Art of Children's Picture Books by Perry Nodelman (University of Georgia Press, 1988)

Writing and Illustrating Children's Books for Publication: Two Perspectives by Berthe Amoss and Eric Suben (Writer's Digest, 2005)

Writing Picture Books: A Hands-On Guide from Story Creation to Publication by Ann Whitford Paul (Writer's Digest Books, 2009)

Writing with Pictures: How to Write and Illustrate Children's Books by Uri Shulevitz (Watson-Guptill Publications, 1997)

Web resources

All Ages Reads – allagesreads.blogspot.com

Association of Booksellers for Children –
 associationofbooksellersforchildren.com

BibliOdyssey – bibliodyssey.blogspot.com

Bloomabilities – bloomabilities.blogspot.com

Blue Rose Girls – bluerosegirls.blogspot.com

Bologna Children's Book Fair – www.bookfair.bolognafiere.it

The Brown Bookshelf – thebrownbookshelf.com

Children's Book Council – cbcbooks.org

Children's Book Council of Australia – cbc.org.au

Children's Illustration – picturebookillustration.blogspot.com

Cover to Cover – valuemakers.info/covertocover_main.html

Cynsations – cynthialeitichsmith.blogspot.com

Drawn! The Illustration & Cartooning Blog – drawn.ca

Embracing the Child – embracingthechild.org/index.html

Eric Carle Museum of Picture Book Art – picturebookart.org

Good Comics for Kids – goodcomicsforkids.com

The Graphic Classroom – graphicclassroom.blogspot.com

Graphic Novel Reporter – graphicnovelreporter.com

Gurney Journey – gurneyjourney.blogspot.com

Guys Read – guysread.com

The Horn Book – hbook.com

Illustration Friday – illustrationfriday.com

International Board on Books for Young People – ibby.org

International Children's Digital Library – en.childrenslibrary.org

JacketFlap – jacketflap.com

Kids Love Comics – kidslovecomics.blogspot.com

lines and colors – linesandcolors.com

Molly Bang – mollybang.com

National Center for Children's Illustrated Literature – nccil.org

National Children's Book and Literacy Alliance – thencbla.org

PaperTigers – papertigers.org

Picturing Books – picturingbooks.com

Poetry for Children – poetryforchildren.blogspot.com

The Purple Crayon – underdown.org

readergirlz – readergirlz.com

Ricochet Jeunes (International Center for Children's Literature
 Studies) – ricochet-jeunes.org

SCBWI France – scbwifrance.com

School Library Journal – schoollibraryjournal.com

Scott McCloud – scottmccloud.com

Seven Impossible Things Before Breakfast – blaine.org/
 sevenimpossiblethings

Society of Children's Book Writers & Illustrators (SCBWI) –
 scbwi.org

Society of Illustrators – societyillustrators.org

The Story Museum – storymuseum.org.uk

TeenReads – teenreads.com

UK Children's Books – ukchildrensbooks.co.uk

Voice of Youth Advocates (VOYA) – voya.com

Contributors list

Steve Adams – adamsillustration.com

Clare Beaton – clarebeaton.co.uk

Carlyn Beccia – carlynbeccia.com, whoballyhoo.com, raucousroyals.com

Mary Jane Begin – maryjanebegin.com

Sophie Blackall – sophieblackall.com, sophieblackall.blogspot.com

Lesley Breen Withrow – lesleybreenwithrow.com, lesleybreenwithrow.blogspot.com

Karen Chilton – ghostgirlsbooks.com

Charlene Chua – charlenechua.com

Nancy Cote – nancycote.com

Eleanor Davis – doing-fine.com

Joanne Dugan – joannedugan.com

Polly Dunbar – pollydunbar.com

Brian Floca – brianfloca.com, brianflocablog.blogspot.com

Betsy Franco – betsyfranco.com

Jack Gantos – jackgantos.com

Liz Goulet Dubois – lizgouletdubois.com

Jean Gralley – jeangralley.com

Piet Grobler – pietgrobler.com

Jannie Ho – chickengirldesign.com

Thacher Hurd – thacherhurd.com

Isol – isol-isol.com.ar

Lisa Jahn-Clough – lisajahnclough.com

Barbara Johansen Newman – johansennewman.com, texandsugar.com

Cheryl Kirk Noll – cherylkirknoll.com

Kara LaReau – bluebirdworks.com, lareausisters.com

Miriam Latimer – miriamlatimer.co.uk

John Lechner – johnlechner.com

Steve Mack – illustrationfarm.com, spotillustration.com

Dr. Kenneth and Sylvia Marantz – arted.osu.edu/personnel/marantz.php

Leonard S. Marcus – leonardmarcus.com

Elizabeth Matthews – elizabethmatthews.info

Gary McCluskey – mccluskeyart.com

Meomi (Vicki Wong and Michael Murphy) – meomi.com, octonauts.com

Judith Moffatt – judithmoffatt.com

Françoise Mouly – toon-books.com

Kelly Murphy – kelmurphy.com

Perry Nodelman – io.uwinnipeg.ca/~nodelman

Judy O'Malley – judyomalley.com

Rui de Oliveira – ruideoliveira.com.br

Matthew Reinhart – matthewreinhart.com

Robert Sabuda – robertsabuda.com

Scott Christian Sava – bluedreamstudios.com, thedreamlandchronicles.com

Susan Sherman – charlesbridge.com

Anne Sibley O'Brien – annesibleyobrien.com; koreanrobinhood.com

Bob Staake – bobstaake.com

Bridget Strevens-Marzo – bridgetstrevens.com

Tessa Strickland – barefoot-books.com

Nicole Tadgell – nicoletadgell.com, nicoletadgell.blogspot.com

Shaun Tan – shauntan.net

Russell Tate – users.bigpond.net.au/thewholepicture/PixelMaster.html

Michael Wertz – wertzateria.com

Steven Withrow – cracklesofspeech.blogspot.com

Nicole Wong – nicole-wong.com

Jane Yolen – janeyolen.com

Glossary

ACRYLIC
Quick-drying synthetic paint that combines properties of oil and watercolor.

ANTHROPOMORPHISM
Practice of conferring human characteristics on nonhuman ideas, creatures, or objects.

ART DIRECTOR
Publishing professional in charge of overall design and production effort.

BITMAP
Resolution-dependent digital images defined as a grid of differently colored pixels.

BOARD BOOK
Book published on durable, hard cardboard generally for small children.

BORDER
Frame used to enclose text or illustrations.

CHAPTER BOOK
Illustrated story book intended for intermediate readers, generally between the ages of 7 and 10.

CLIMAX
Point of highest tension or drama, or greatest change, in a story.

COLLAGE
Artwork made from an assemblage of different materials to create a whole.

COLOR WHEEL
Organization of color hues around a circle, showing relationships between primary, secondary, and complementary colors, etc.

COMICS
Graphic form in which a sequence of static images, often incorporating text, is arranged in space to convey a narrative or idea.

COMPOSITION
Plan, placement, or arrangement of art elements on a page or throughout a picture book.

CONCEPT BOOK
Genre of picture book meant to teach basic concepts such as shape, color, order, like/unlike, etc.

CONTOUR
Structural outline that indicates form or volume.

CUT PAPER
Compositions made from carefully cut and arranged paper.

DUMMY
Three-dimensional model of the picture book with the exact trim size and number of pages.

FORESHORTENING
Optical illusion that an object appears shorter than it actually is because it is angled toward the viewer.

FORMAT
Shape, size, and visual characteristics of a book.

GENRE
Type or classification of story based on shared content and conventions.

GESTURE DRAWING
Simple drawings of an object that convey only the object's most essential details.

GOUACHE
Opaque watercolor paint.

GRAPHIC NOVEL
Form of unified comics narrative or book-length work of comics fiction.

GUTTER
Open space between panels in a comic, or between pages of a book at the spine.

HATCHING
Use of parallel lines to create shading effects. Crosshatching involves the use of crossed lines.

HORIZON LINE
Imaginary line where earth and sky meet.

HUE
Pure color without tint (added white) or shade (added black).

IINTERNATIONALISM
Quality of being multinational, or globally oriented, in character, principles, concern, or attitude.

LAYOUT
Organization of text and pictures.

LINE ART
Artwork made of solid black and white with no continuous tones or grays.

MANGA
Japanese comics and print cartoons, as well as international works inspired by them.

MANUSCRIPT
Text submitted to a publisher or printer in preparation for publication.

MEDIUM
Materials and techniques used by artists.

MIXED MEDIA
Use of two or more media in a composition.

MOOD
Emotional atmosphere of a scene or story.

MULTICULTURALISM
Quality of racial, cultural, and ethnic diversity in character, principles, concern, or attitude.

NEGATIVE SPACE
Space around and between the subject(s) of an image.

NOVELTY BOOK
Genre of picture book including pop-ups, movable books, touch-and-feel books, and toy books.

OIL
Slow-drying paint created from mixing colored pigments with an oil base.

PACE
Rhythm, tempo, or flow of events in a story.

PALETTE
Range of colors in a given work or body of work.

PANEL
Framed image in a comic book, comic strip, or picture book meant to segment the passage of time or draw attention.

PASTELS
Pigments formed into manageable sticks.

PERSPECTIVE
Approximate representation, on a flat surface, of an image as it is perceived by the eye.

PICTURE BOOK
Form of children's literature that combines words and pictures with differing degrees of interdependence.

PIXEL
Picture element. Smallest graphic unit that can be displayed on screen, usually a single-colored dot.

PLOT
Order of logically connected events in a narrative.

POINT OF VIEW
Perspective of the narrative voice.

PORTFOLIO
An artist's set of samples for consideration by publishers.

PROTAGONIST
Central or main character (hero) in a story. Opposite of antagonist.

RESOLUTION
Number of pixels in a unit of measure.

SATURATION
Relative strength or intensity of a color.

SETTING
Time, location, and circumstances in which a story takes place.

SILHOUETTE
Outline and featureless interior of an object, usually shown in black.

SPREAD
Two adjacent, facing pages in a book, magazine, or other publication.

STIPPLING
Use of small, closely spaced dots to create shading effects.

STORYBOARD
Series of sequential illustrations used to plan a picture book.

SUPPORT
Material or surface on which a medium is applied.

SYMMETRY
Balance of form across a dividing line or axis.

TEMPERA
Paint made from ground pigment bound together with egg yolk and water.

TEXTURE
Perceived surface quality of an artwork.

THEME
Unifying subject or idea of a story or visual artwork.

THUMBNAIL
Small preparatory sketch drawn to establish layout and composition.

TRANSPARENCY
Degree to which a surface allows light to pass through. Opposite of opacity.

TRIM SIZE
Outermost dimensions of a printed book.

TYPOGRAPHY
Art and technique of setting and arranging type with specifications provided by a designer or art director.

VALUE
Measure of where an individual color lies along the lightness–darkness spectrum.

VANISHING POINT
Point in a perspective drawing to which parallel lines appear to converge.

VECTOR
Resolution-independent graphic file composed of line and curve segments created in a vector editor.

VIGNETTE
Small inset illustration, often without a border.

WATERCOLOR
Pigment bound by a water-soluble medium such as gum arabic that can be diluted with water until it is translucent.

YOUNG ADULT NOVEL
Fiction written for or marketed to adolescent readers, generally between the ages of 12 and 18.

Index

Acknowledgments

Steven and Lesley thank the contributing artists, writers, and children's book experts for their insights and images. We dedicate this book with love to our daughter, Marin, who will always be our inspiration.

Picture credits

Pages 1 and 3 © Bridget Strevens-Marzo, page 2 © Piet Grobler
Contents page © Steve Mack, © Sophie Blackall

Introduction: pages 6 and 7 © Lesley Breen Withrow

The Picture Book:
pages 10–13 © Lesley Breen Withrow
pages 14 and 15 © Charlene Chua; © Russell Tate (*Aron the Artist:* Ibis Publishing Australia; *Time Travel: Ship Ahoy!:* Thomson Publishing Australia)
page 17 © Liz Goulet Dubois; © Scott Christian Sava; © Russell Tate (Thomson Publishing Australia)
pages 18 and 19 © Nicole Tadgell (Moon Mountain Publishing); © Sophie Blackall; © Nancy Cote
pages 20 and 21 © Russell Tate (Cengage Publishing Australia); © Lesley Breen Withrow; © John Lechner
page 22 photo by Sonya Sones

Art and Craft:
pages 26 and 27 © Lesley Breen Withrow
pages 28 and 29 © Nancy Cote
pages 30 and 31 © Russell Tate (Thomson Publishing Australia); © Lesley Breen Withrow
pages 32 and 33 © Scott Christian Sava; © Charlene Chua; © Jannie Ho; © Russell Tate (Thomson Publishing Australia)
pages 34 and 35 © 2006 Joan Gannij and Clare Beaton. Reproduced by kind permission of Barefoot Books (www.barefootbooks.com).

Storytelling:
pages 40 and 41 © Brian Floca (Richard Jackson Books/Atheneum); © John Lechner; © Scott Christian Sava
pages 42 and 43 © Sophie Blackall; © Lesley Breen Withrow; © Anne Sibley O'Brien (*Jamaica Tag-Along,* written by Juanita Havill, Houghton Mifflin)
pages 44 and 45 © Russell Tate (Cengage Publishing Australia); © Lesley Breen Withrow
pages 46 and 47 © Lesley Breen Withrow; © Elizabeth Matthews
pages 48–53 © Steven Withrow and Lesley Breen Withrow
pages 54 and 55 © Anne Sibley O'Brien (Charlesbridge Publishing, Inc.)
pages 56 and 57 © 2007 Jennifer Wojtowicz and Steve Adams. Reproduced by kind permission of Barefoot Books (www.barefootbooks.com).

Traditional Tools:
pages 62–65 © Lesley Breen Withrow
pages 66–69 © Cheryl Kirk Noll. Used by permission of the illustrator and Apprentice Shop Books, LLC.
pages 70 and 71 © Nancy Cote
pages 72 and 73 © Judith Moffatt
pages 74 and 75 © Barbara Johansen Newman; © Lesley Breen Withrow; Early and final stages of a pop-up illustration from *ENCYCLOPEDIA PREHISTORICA: DINOSAURS.* Copyright © 2005 by Robert Sabuda and Matthew Reinhart. Reprinted by permission of the publisher, Candlewick Press, Somerville, MA.
pages 76 and 77 from *Tex & Sugar: A Big City Kitty Ditty* © 2007 by Barbara Johansen Newman. Used with permission from Sterling Publishing Co., Inc.
pages 78 and 79 © Sophie Blackall
pages 80–83 © Lisa Jahn-Clough (*Little Dog;* Houghton Mifflin, 2006)
pages 84–95 © Mary Jane Begin
pages 96–99 © Cover and five interior illustrations reproduced with permission from *The Arrival* by Shaun Tan, Lothian Children's Books, an imprint of Hachette Australia, 2006.
pages 100–103 © Brian Floca (Richard Jackson Books/Atheneum)
pages 104–107 © Polly Dunbar
pages 108–111 © Piet Grobler (*Ballade van De Dood,* written by Koos Meindert and Harrie Jekkers; Lemniscaat)
pages 112–115 © Thacher Hurd
pages 116–119 © Rui de Oliveira
pages 120–123 © 2008 Miriam Latimer. Reproduced by kind permission of Barefoot Books (barefootbooks.com).
pages 124 and 125 Cover and pages from *Maxwell's Mountain.* Text copyright © 2006 by Shari Becker. Illustrations copyright © 2006 by Nicole Wong. Used with permission by Charlesbridge Publishing, Inc. All rights reserved.

Digital Dreams:
pages 130–135 © Lesley Breen Withrow
pages 136 and 137 © Joanne Dugan Photography, LLC/Abrams
pages 138–141 © Bridget Strevens-Marzo
pages 142–145 © Steve Mack, except cover of *Hide-and-Seek Dinosaurs!,* which is reprinted by permission of Chronicle Books.
pages 146–149 © Carlyn Beccia
pages 150–153 From *THE DONUT CHEF* by Bob Staake, © 2008 by Bob Staake. Used by permission of Golden Books, an imprint of Random House Children's Books, a division of Random House, Inc.
pages 154–157 © 2008 MEOMI: Vicki Wong and Michael Murphy (published by Immedium)
pages 158–161 © Jannie Ho
pages 162–165 © Jean Gralley

Multiple Markets:
pages 168 and 169 © Liz Goulet Dubois
pages 170 and 171 © Karen Chilton and Gary McCluskey
pages 172 and 173 © John Lechner; © Scott Christian Sava
pages 174 and 175 © Liz Goulet Dubois; © FRED, design by Liz Goulet Dubois
pages 176 and 177 © Elizabeth Matthews

Additional Resources:
page 182 photo by Gary Harwood, Kent State University